IMAGES
of America

THEATRES OF
SAN FRANCISCO

To Jess)
who lives it!
Big Hugs,
Pro

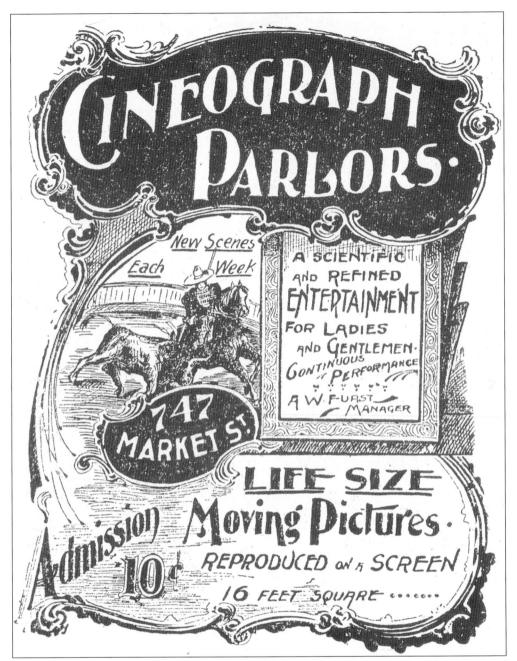

Shortly after the turn of the century, the new marvel of motion pictures, "a scientific and refined ENTERTAINMENT for Ladies and Gentlemen," began to be exhibited publicly in "Cineograph Parlors" such as this one at 747 Market Street in 1905. The following pages will give you a bird's-eye view of what happened during the next 100 years.

IMAGES
of America

THEATRES OF
SAN FRANCISCO

Jack Tillmany

Copyright © 2005 by Jack Tillmany
ISBN 0-7385-3020-4

Published by Arcadia Publishing
Charleston SC, Chicago IL, Portsmouth NH, San Francisco CA

Printed in the United States of America

Library of Congress Catalog Card Number: 2005928089

For all general information contact Arcadia Publishing at:
Telephone 843-853-2070
Fax 843-853-0044
E-mail sales@arcadiapublishing.com
For customer service and orders:
Toll-Free 1-888-313-2665

Visit us on the Internet at www.arcadiapublishing.com

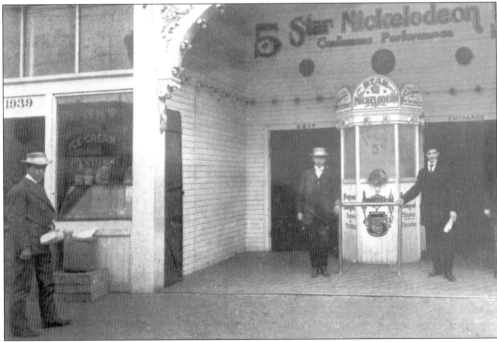

The Star Nickelodeon at 1939 Post Street opened in 1907 and was typical of the dozens of similar venues that sprung up throughout the city after the devastating earthquake and fire of April 1906. Most of them only lasted a year or two, but a handful had amazing survival skills and a few can still be found today.

CONTENTS

ACKNOWLEDGMENTS

All pictures in this book are from the author's personal collection. I am indebted to the many photographers, known and unknown, professional and amateur, who recorded these images over the years, and particularly to my friends Tom Gray and Fred Beall, without whose dedication and determination, many of these long gone sites would now be totally undocumented in any visual form. My heartiest thanks, also, to the late Preston Kaufmann and to Greg Gaar, whose vast and unique photo collections I have often tapped, and through which, I have, on more than one occasion, found the unfindable. Thanks, too, to David Kiel, who spent long hours meticulously detailing local long-run records that have provided me with no end of informative and invaluable statistics.

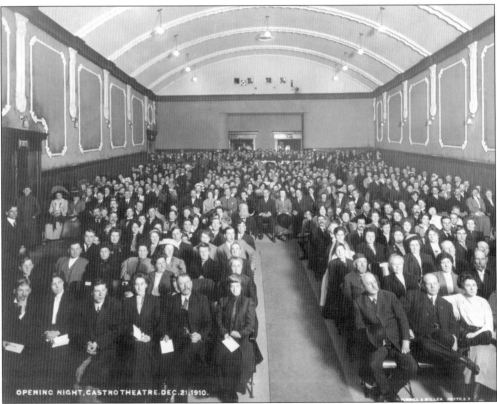

OPENING NIGHT, CASTRO THEATRE, DEC. 21, 1910.

On Wednesday, December 21, 1910, a capacity crowd greeted the new Castro Street Theatre, built and operated by the three Nasser Brothers, Abraham, Albert, and Sam. It was their third venture into film exhibition, and its success prompted their building of today's Castro Theatre in 1922. Today it's Cliff's Variety Store (see also page 108).

INTRODUCTION

Irving Berlin was right: There's no business like show business. A theatre is an inanimate object, a pile of brick and mortar that takes on a personality all its own as a result of what's being presented inside. Its success or failure, life or death, depends on the public's acceptance of what's being offered and their willingness to pay money to see it. Theatres close for one reason only: the public fails to show up. (Oh yes, there are earthquakes too, and, occasionally, as we shall see, the structure simply starts crumbling apart of its own accord.) But when the people stop coming, the doors close and the lights go out. Why once-filled seats suddenly become empty ones would fill a book twice this size, and that's not our purpose here. However, some of the more obvious reasons will inevitably pop up.

San Francisco has always been considered a "good theatre town." The nature of its inhabitants has always been to seek entertainment outside the home, particularly in the evening hours. Theatres have always been there to provide just that and will continue to do so despite what technological marvels may arrive to provide homebound diversions. Which theatres thrive or fail, and what films are shown, reflect the fickle tastes of the ticket buyers. It's really as simple as that. Times change, tastes change, people change, and theatre operators face a constant challenge to keep up. Having been there and done that, let me tell you, it's a tough call. Fifty years ago, virtually every man, woman, and child went to the movies regularly, meaning at least once a week. Today, that number has dwindled to somewhere around 15 percent of the total adult population who attend with any regularity at all, meaning maybe once a month or less. Like them or not, multiplexes are here to stay, and are the only feasible economic solution to providing today's moviegoers with the widest possible selection of films in a state-of-the-art technological environment.

But you want to know about the way it was, not the way it is, so let's get on with the show. The earthquake that struck San Francisco on the morning of April 18, 1906, and the devastating fire that followed was the end of one era and the beginning of another in many ways. By coincidence, it also divided two centuries, two cultures, and two technologies. For the purposes of this book, we are dealing here with theatres of the post-1906 era, although there is still one pre-quake survivor still standing, and duly noted. The 20th century is history now, so let's take a look back and see just where and how San Franciscans chose to find their sources of entertainment during those 10 most remarkable decades.

Within the limitations of the book, I have tried to be as inclusive as possible. A few sites that I would have liked to include seem to have eluded photographers completely, though there is always hope. Somewhere in someone's attic or basement or bottom dresser drawer is that one terrific shot of the Round-Up on Market Street or the Liberty on Broadway or the Rita on Church Street or the Cameo on Sixteenth Street or the Lincoln on Sixth Avenue or the Point in Hunters Point or the Terrace Drive-In on Alemany Boulevard that has escaped me up until now. Early exterior views, before remodeling, as well as interior shots, seem to be missing in all too many cases. Such finds will be appropriately welcomed and rewarded!

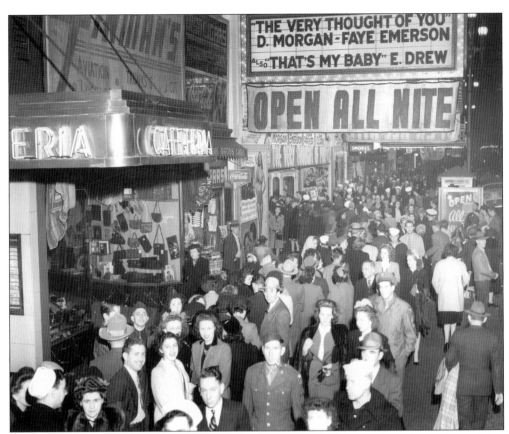

Market Street during the World War II years was alive with masses of people, night and day, most of them going to and from the movies, as seen in this 1944 shot in front of the Paramount Theatre. War workers, who worked around the clock in shipyards and in other wartime-related activities, were hungry for fun and entertainment to take their minds off the grim struggle for survival that engulfed the world for the better part of the decade. Movies had always provided a very welcome and necessary escape from reality and, at this particular time, were needed and embraced more than ever.

One

MARKET STREET

It was called the Great White Way because of the non-stop stream of lights that flooded the street from dusk to midnight, many of them provided by the array of movie theatres that held court for six incredible blocks. For over 50 years, from the mighty 4,650-seat Fox at 1350 Market Street to the humble 300-seat Silver Palace at 727 Market Street, a dozen and a half venues of every size and demeanor beckoned patrons to a grand total of over 25,000 seats, approximately one-quarter of the San Francisco theatre total. Every first-run American-made film opened on Market Street and nowhere else in the city; the neighborhood theatres got them later. But starting in the mid-1950s with *Oklahoma!* at the Coronet, distribution policies started to change, and big new films started bypassing Market Street and premiering more and more in the outlying areas. Hence, the lights started going out in the 1960s, and for the next 40 years, Market Street got dimmer and dimmer.

Today there are a few survivors. The lights are on again at the Orpheum, Golden Gate, and Warfield, all now upgraded and offering live entertainment, with the benefit of office buildings upstairs to help defray the ever escalating costs of operation. The former United Artists, renamed the Market Street Cinema 30 years ago, offers more exotic forms of live diversion, as do the little Regal (now L.A. Gals), and Biograph, now Crazy Horse Gentlemen's Club. Market Street goes on, greeting the new century even as historic streetcars from the previous one still rumble by.

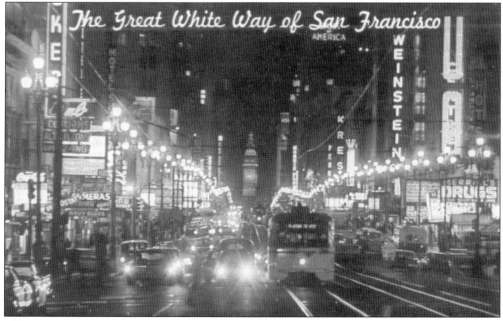

This *c.* 1966 photograph shows Market Street, looking east from Seventh. *The Sound of Music* is already in its second year at the United Artists. Department stores like Weinstein, Kress, and Penney's still welcome nighttime shoppers, and a crowded N Judah heads westward, taking people home.

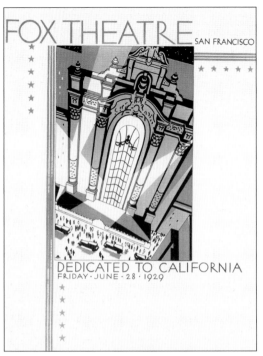

FOX THEATRE SAN FRANCISCO

DEDICATED TO CALIFORNIA
FRIDAY · JUNE · 28 · 1929

The Fox Theatre opened on June 28, 1929, a $5-million, 4,650-seat movie palace in every sense of the word. Designed by Thomas W. Lamb, it was to be San Francisco's largest, finest, and ultimately, saddest memento of 1920s extravagance. Its untimely end still brings tears to the eyes not only to those old enough to remember it in its heyday, but also to those who know it only by reputation. The Fox's architectural grandeur, thankfully, is preserved in countless photographs. The cover image shows the Fox at the peak of its popularity as it celebrated its first anniversary in the summer of 1930.

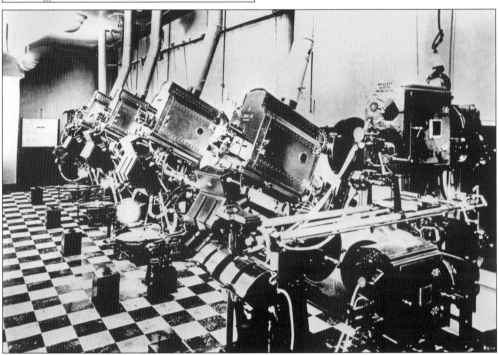

Above the top balcony, over 200 feet from the original 29-by-22-foot screen (believed to be the longest projector-to-screen distance in the United States), four projectors and a brenograph (a lighting effects machine) are aimed at a 27-degree angle towards the screen below. Note the Vitaphone turntable attachments, used to accommodate films with sound tracks still being recorded on disk.

10

The ornate grandeur of the Fox
Lobby shows well in this view
looking outwards towards
Market Street.

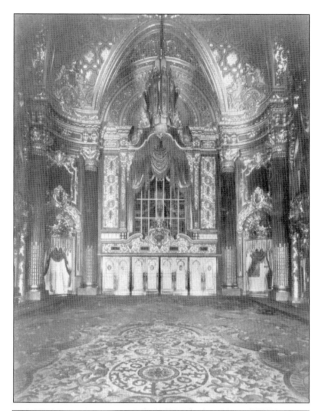

The Fox lobby is pictured here
from the same point, looking into
the theatre and towards the grand
staircase. Note the Fox emblem in
the carpet.

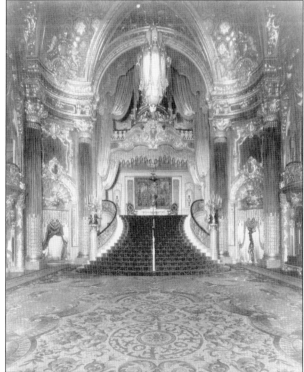

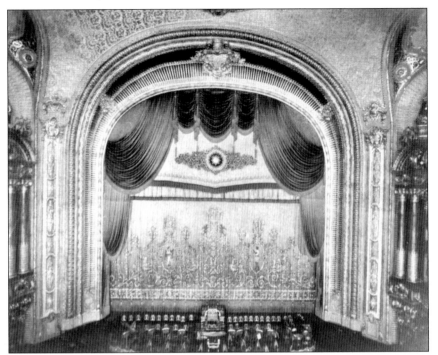

The Fox proscenium, 64 by 40 feet high, utilized three of the largest and heaviest curtains ever hung in a theatre. The orchestra pit accommodated not only a full orchestra but a Wurlitzer pipe organ as well.

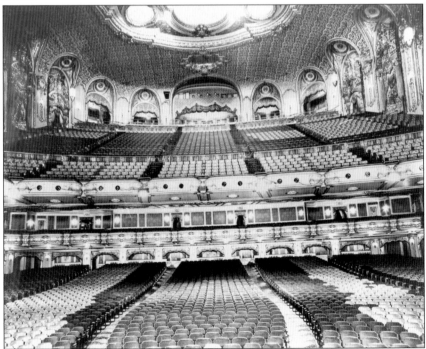

There were 4,650 seats available for Fox patrons. The theatre advertised it was the largest west of the Mississippi, and indeed it was.

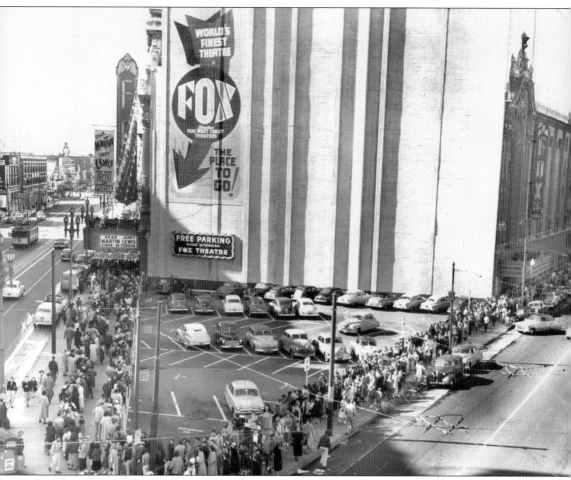

In February 1952, Dean Martin and Jerry Lewis appeared in person for a single week at the Fox Theatre. There were five shows a day—six on Saturday and Sunday—and the crowds kept coming. An estimated 90,000 tickets were sold, for an all-time San Francisco attendance record yielding a box office gross of $123,000. That might not sound like much, but this was an era when adult tickets were only a little more than a dollar apiece, and children about half that.

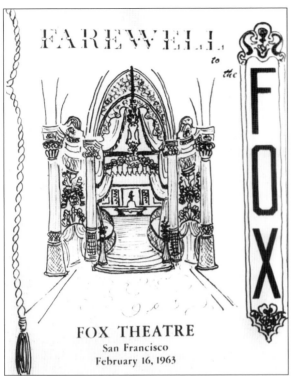

FAREWELL to the FOX

FOX THEATRE
San Francisco
February 16, 1963

After 10 years of continually declining patronage (due in no small part to the incredibly poor quality of the films being presented), the Fox hosted a combination wake and farewell party that drew a capacity crowd—the first in a long, long time. After an evening of cheers and tears, the Fox was laid to rest at the age of 33 years, 7 months.

Proposition I, listed on the ballot of November 7, 1961 as the "Fox Theatre Acquisition" for the sum of $1,100,000 by the City of San Francisco for future use as a convention center and/or performing arts center, was rejected by the voters by a two-thirds majority. The rest, as they say, is history. For the complete Fox Theatre story, the author heartily recommends Preston Kaufmann's magnificent "Fox: The Last Word . . . story of the world's finest theatre."

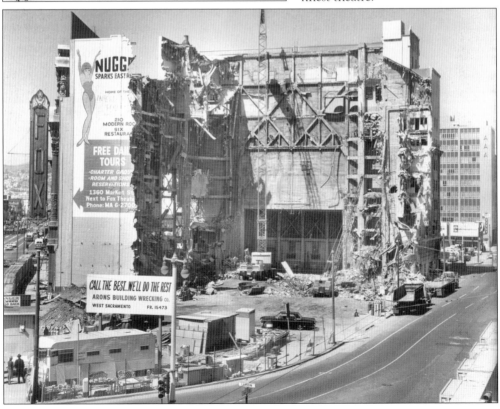

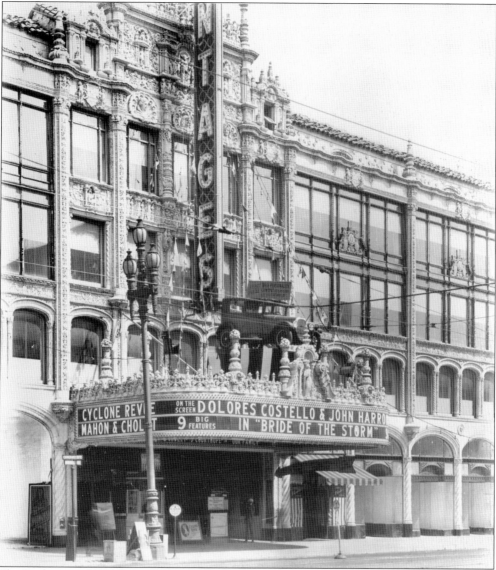

The Orpheum at 1182 Market Street is a Gothic-Moorish design by B. Marcus Pritica for Alexander Pantages. It opened as the Pantages on February 20, 1926, offering vaudeville and motion pictures, and was described as "a copy in part of the Cantabrian Cathedral of Leon." It was renamed Orpheum in 1929 and survives today as a beautifully restored live venue, operated by the Shorenstein Hays Nederlander Organization.

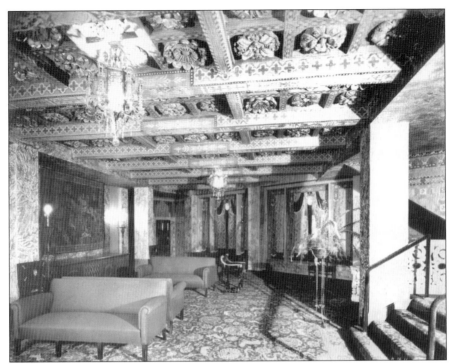

The ornate but tasteful mezzanine of the Pantages/Orpheum was a splendid sight. Here it is as it originally looked in 1926.

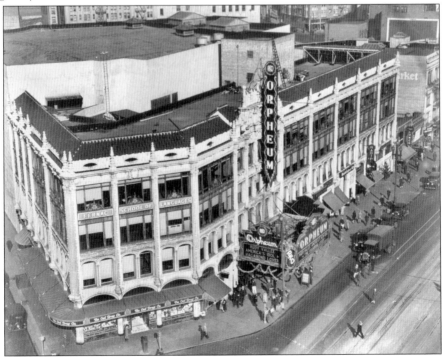

It's Christmastime in 1929, and female hearts skip a beat as crooner Rudy Vallee ("America's Idol") appears in his first talkie feature, *The Vagabond Lover*, on the RKO Orpheum screen.

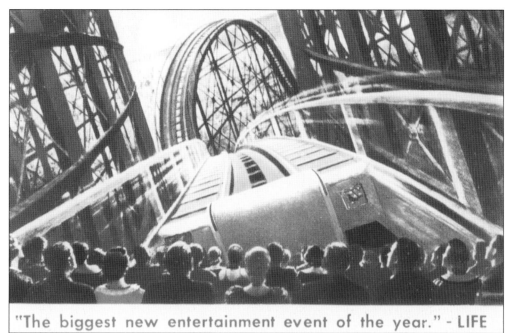

"The biggest new entertainment event of the year." - LIFE

Twenty-four years later, on Christmas Day 1953, *This is Cinerama* opens in San Francisco at the Orpheum. Cinerama was a technique wherein features were photographed on three separate strips of film, and shown via three separate projectors running simultaneously. It began an 83-week, reserved-seat engagement, to be followed during the next 10 years by six more big-screen Cinerama extravaganzas, finishing up with *How the West Was Won*, which closed in December 1963.

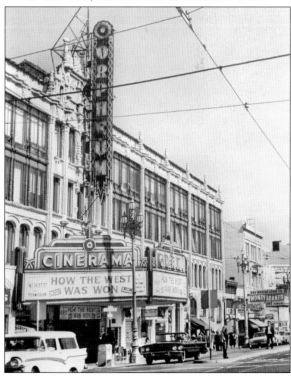

How the West Was Won was the last Cinerama feature to be filmed in the three-camera method. Afterwards the name "Cinerama" lived on, but all the films advertised as such were simply some form of single-strip 70-millimeter film projected onto a giant curved screen.

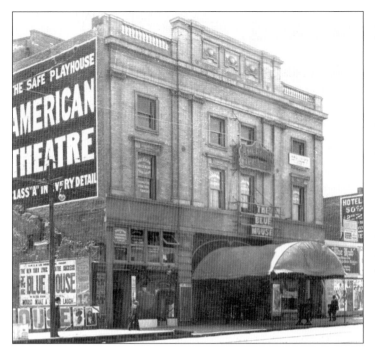

The Embassy at 1125 Market Street designed by the Reid Brothers, was under construction (as the Bell) at the time of the 1906 earthquake. The facade survived, and it finally opened (as the American) on January 21, 1907. It had multiple personalities, being known during the next few years as the Rialto, the Rivoli Opera House, and in 1927, renamed the Embassy. It fell victim to the October 1989 Loma Prieta earthquake; the building was condemned and subsequently torn down.

Talkies came to San Francisco amid great fanfare. Here, the Embassy hosts Vitaphone, Warner Brothers' revolutionary process that brought sound to the silent screen. Phonograph disks were synchronized with the film as it was being projected, and everything that could go wrong did, as anyone who's seen *Singin' in the Rain* knows only too well. In the meantime Fox Films introduced Movietone (with a soundtrack embedded on film) and Vitaphone soon bit the dust. Warner Brothers kept the name alive long after they abandoned the actual process itself, however, so it is still well known.

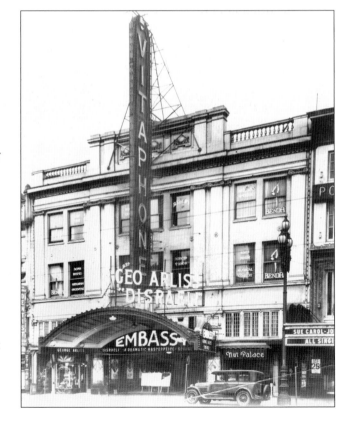

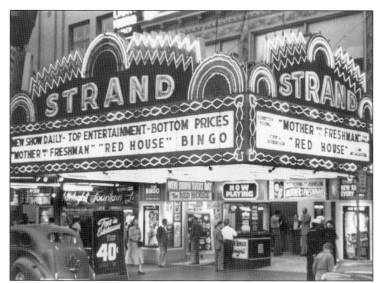

Next door to the Embassy at 1127 Market Street was the Strand, which opened in 1917 as the Jewel and became the Strand in 1928. During its glory days, it offered "Top Entertainment—Bottom Prices," a daily program change consisting of two worthwhile (although not quite new) feature films, plus bingo for 40¢. Although it ended up running "adult" films via projected video, the Strand survived over the years but had become a haven for druggies, prostitutes, and the lowest of the Market Street low. It was permanently closed after a vice raid in April 2003, more a victim of its own environment than anything else. The Strand was the last film theatre to operate on Market Street.

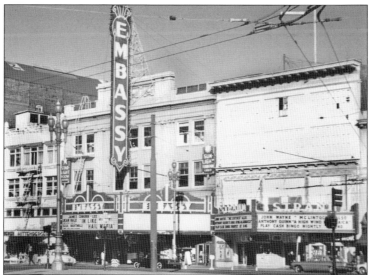

Neighbors for over 70 years, the Embassy and Strand were friendly competitors for the Market Street movie dollar. Dan McLean took over the Embassy in 1933 and developed the popular Ten-O-Win game (a game of chance where you had to have both the right color and the right number to win). This was a welcome perk to Depression-weary audiences and still a crowd pleaser 30 years later. Often the theatre would be filled to capacity, and the game was piped out onto the street via loudspeakers, so those waiting in line to get in afterwards could still play the game before they entered.

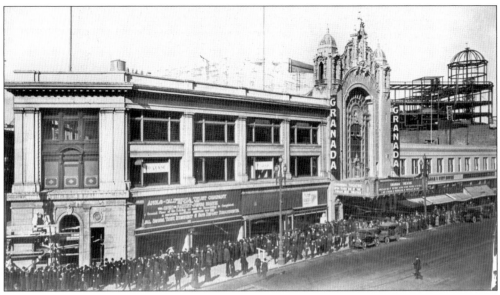

In this photo from November 17, 1921, opening-day crowds greet the Andalusian splendor of the Granada Theatre at 1066 Market Street, designed by Alfred Henry Jacobs. Gino Severi directed the orchestra, Oliver Wallace commanded the Wurlitzer organ, and the operating staff numbered 122 people.

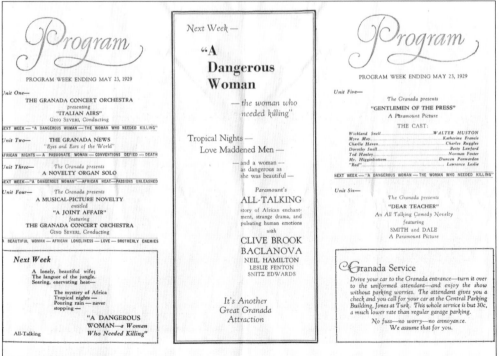

Program

PROGRAM WEEK ENDING MAY 23, 1929

Unit One—
THE GRANADA CONCERT ORCHESTRA
presenting
"ITALIAN AIRS"
GINO SEVERI, Conducting

NEXT WEEK — "A DANGEROUS WOMAN — THE WOMAN WHO NEEDED KILLING"

Unit Two— THE GRANADA NEWS
"Eyes and Ears of the World"

AFRICAN NIGHTS — A PASSIONATE WOMAN — CONVENTIONS DEFIED — DEATH

Unit Three— *The Granada presents*
A NOVELTY ORGAN SOLO

NEXT WEEK—"A DANGEROUS WOMAN"—AFRICAN HEAT—PASSIONS UNLEASHED

Unit Four— *The Granada presents*
A MUSICAL-PICTURE NOVELTY
entitled
"A JOINT AFFAIR"
featuring
THE GRANADA CONCERT ORCHESTRA
GINO SEVERI, Conducting

A BEAUTIFUL WOMAN — AFRICAN LONELINESS — LOVE — BROTHERLY ENEMIES

Next Week

A lonely, beautiful wife;
The languor of the jungle.
Searing, enervating heat—

The mystery of Africa
Tropical nights —
Pouring rain — never
stopping —

"A DANGEROUS
WOMAN—*a Woman
Who Needed Killing"*

All-Talking

Next Week —

"A
**Dangerous
Woman**

— *the woman who
needed killing"*

Tropical Nights —
Love Maddened Men —

— and a woman —
as dangerous as
she was beautiful —

Paramount's
ALL-TALKING
story of African enchant-
ment, strange drama, and
pulsating human emotions
with
CLIVE BROOK
BACLANOVA
NEIL HAMILTON
LESLIE FENTON
SNITZ EDWARDS

*It's Another
Great Granada
Attraction*

Program

PROGRAM WEEK ENDING MAY 23, 1929

Unit Five—
The Granada presents
"GENTLEMEN OF THE PRESS"
A Paramount Picture

THE CAST:

Wickland Snell	WALTER HUSTON
Myra May	Katherine Francis
Charlie Haven	Charles Ruggles
Dorothy Snell	Betty Lawford
Ted Hanley	Norman Foster
Mr. Higginbottom	Duncan Penwarden
"Red"	Lawrence Leslie

NEXT WEEK—"A DANGEROUS WOMAN — THE WOMAN WHO NEEDED KILLING"

Unit Six—
The Granada presents
"DEAR TEACHER"
An All Talking Comedy Novelty
featuring
SMITH and DALE
A Paramount Picture

Granada Service

*Drive your car to the Granada entrance—turn it over
to the uniformed attendant—and enjoy the show
without parking worries. The attendant gives you a
check and you call for your car at the Central Parking
Building, Jones at Turk. This whole service is but 30c,
a much lower rate than regular garage parking.*

*No fuss—no worry—no annoyance.
We assume that for you.*

A typical Granada program for May 1929 is shown here. As usual, the following week's attraction seems more interesting than the current one, a curious situation that still holds true today. With an "All Talking" lineup that promised among other things, "Tropical nights, love maddened men, and a woman who needed killing," how could one go wrong?

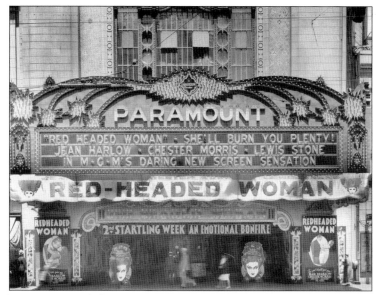

The Granada was renamed the Paramount in 1931 (note the all-neon marquee letters) and pulled out all the stops for the 1932 pre-code bonfire *Red Headed Woman*, starring Jean Harlow. This one delivered all it promised, riled the censors, and made nothing but money in the true Hollywood tradition. Thirty years later, it was deemed "unacceptable" for television showing, but it is still with us today in every pre-code film festival, connoisseur's videotape library, and on Turner Classic Movies.

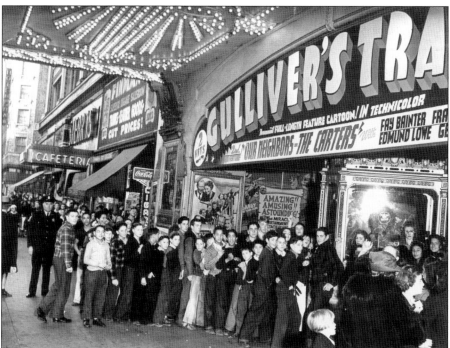

It's Christmastime in 1939, and kids are lined up in front of the Paramount for Max Fleischer's animated *Gulliver's Travels* in three-strip Technicolor. Going downtown to a movie was something "special" in those days, and these kids look like they're loving it.

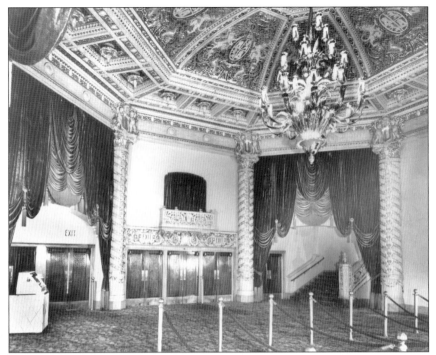

The Paramount lobby is seen here as it looked in the mid-1940s. The ropes are up to accommodate lines of people who will soon be waiting for seats to become available once the auditorium is filled, as it almost always was.

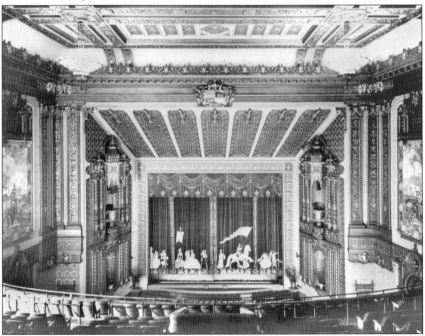

The Granada/Paramount interior shows off another example of Market Street movie palace grandeur. Spanish conquistadors parade across the stage against a blue velvet curtain, surrounded by decor only found in storybooks and ornate 1920s theatres.

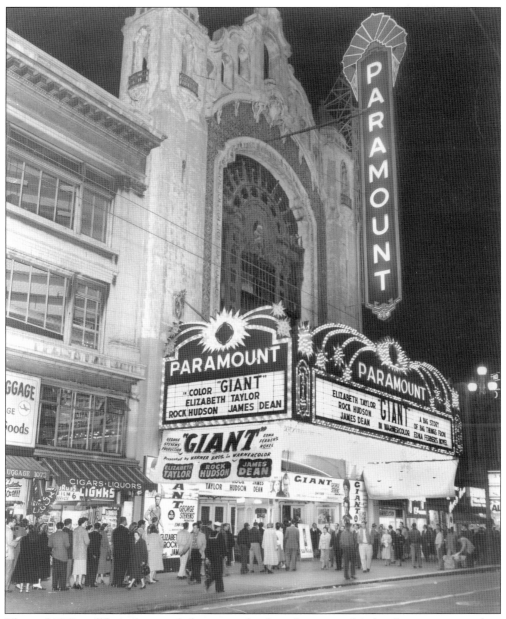

The mid-1950s still brought crowds downtown for the right picture. Market Street was in its glory in the fall of 1956 as ticket-buyers line up for *Giant*, but less than 10 years later, in April 1965, the doors closed for the last time and the Paramount was torn down without delay.

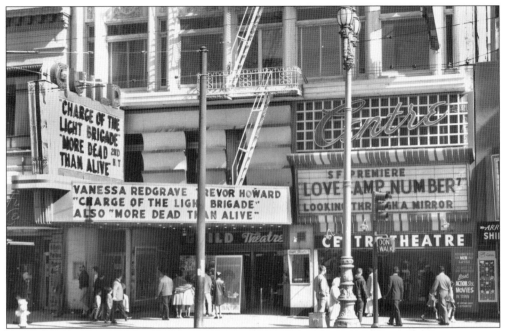

Some theatres were called "grind houses" because they ground out celluloid nonstop from morning to midnight. Every city had its share, and they were always downtown. The programming was not as haphazard as one might think—action, adventure, mystery, comedy, horror, and war were the favorite genres. Audiences were primarily local males, many of whom lived in downtown apartments and hotels, and visitors from the service, strolling up Market in search of a good movie and maybe a taste of home. The Guild (1925–1987, originally the Egyptian, later the Pussycat) and Centre (1944–1987, formerly the Round-Up) were next door to the United Artists, on Market opposite Jones Street, and operated with a variety of policies, ending up with "adult" films in the 1970s and 1980s. Today both locations are retail shops.

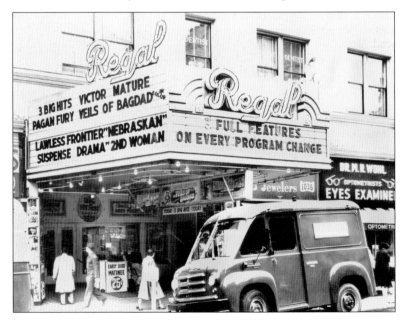

The Regal at 1046 Market Street, between Jones and Taylor Streets, opened in 1925 as the Pompeii and was renamed Regal in 1936. In the 1970s, it went "adult" and was operated by the Mitchell Brothers as the Bijou. Eighty years later, it still survives but offers flesh in lieu of film, as L.A. Gals.

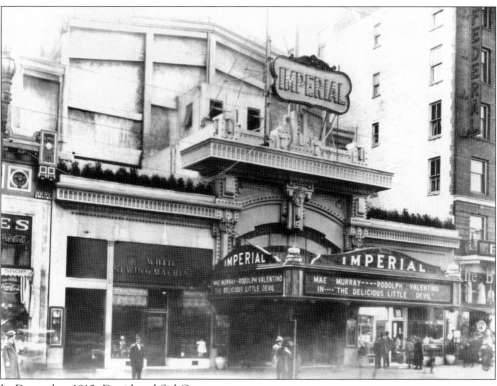

In December 1912, David and Sid Grauman, a father-and-son business team, opened the Imperial, designed by Cunningham and Polito, at 1077 Market Street, and it immediately became one of downtown's most popular sites. Today, as Market Street Cinema, it describes itself as "San Francisco's Largest Live Sex Emporium." Cellulite has replaced celluloid, and its cumbersome facade, bawdily painted in luminous red and blue and still quite identifiable, testifies to another example of survival in the fast lane.

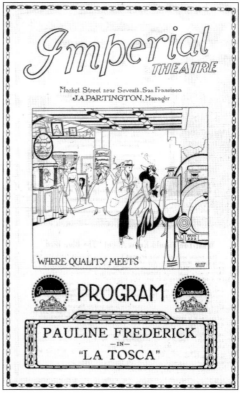

This 1918 program for Pauline Frederick (shown on the screen) in *La Tosca*, gives an imaginative view of Market Street moviegoers that seems to be at odds with today's environment and clientele. But that's progress, or so they say.

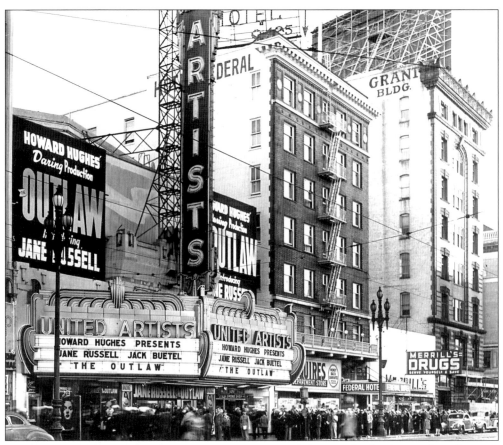

A lineup of ticket-buyers, heavily laden with sailors, eagerly awaits a peek at Jane Russell and her highly publicized attributes in Howard Hughes' notorious *The Outlaw* in mid-1946. The Catholic Church put this one at the top of its "condemned" list, providing a surefire guarantee to draw maximum crowds.

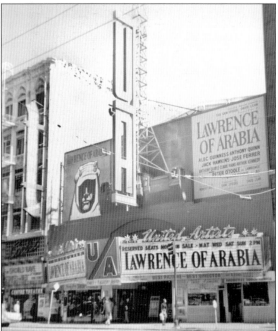

The United Artists was always known for its long runs. *Lawrence of Arabia* ran through most of 1963 (47 weeks), preceded in 1962 by *West Side Story* (46 weeks), and followed in 1965–1966 by the phenomenal *Sound of Music* (92 weeks). Try to imagine one film running at one theatre, on a reserved-seat ticket basis, for nearly two years, and you will get an idea of what Market Street was all about.

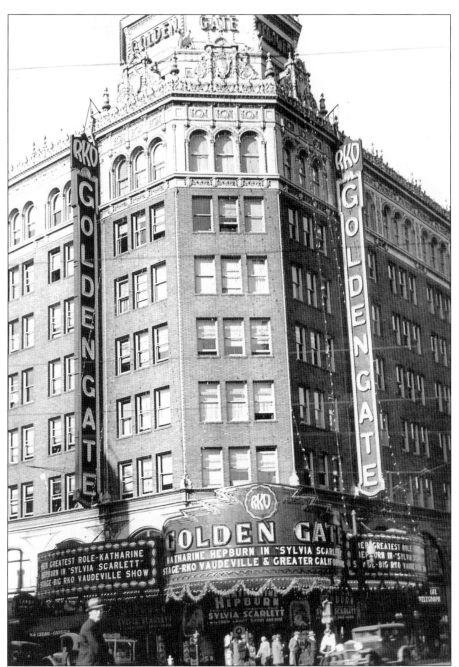

The year 1922 was magic for San Francisco theatres. No less than four major houses built that year survive and prosper today: the Golden Gate, Warfield, Castro, and Curran. The Golden Gate at 2 Golden Gate Avenue opened on March 26, 1922, and was designed by G. Albert Lansburgh. It had a seating capacity of 2,844, surpassed only by the Fox, which opened seven years later. The Golden Gate's programming was a winning combination of vaudeville and first-run motion pictures. It frequently offered stage appearances by the stars of the films currently being offered, as well as by big bands and the top recording artists of the era, a policy that endured into the 1950s. This photograph is from December 1935.

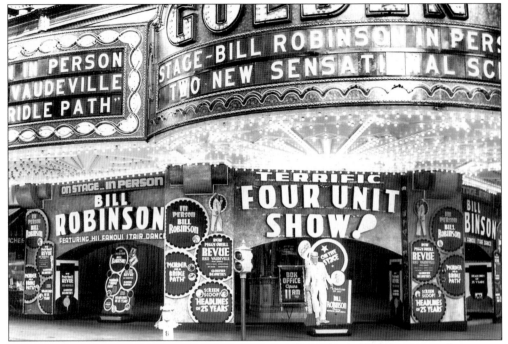

Flashy fronts were Market Street musts. This 1936 image shows the Golden Gate's way of attracting patrons to see Bill Robinson on the stage along with the Peggy O'Neill Revue and RKO's *Murder on a Bridle Path* on the screen.

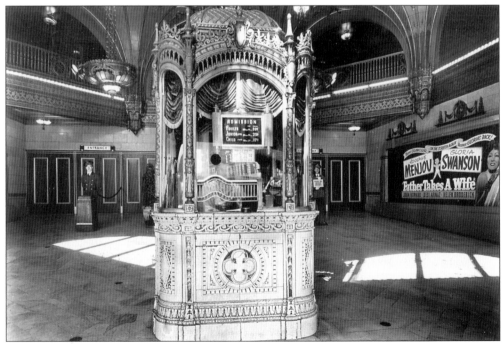

The elaborate Golden Gate box office is seen here in 1941. Matinee prices were 37¢ for adults, 25¢ for juniors, and 17¢ for children. On the screen, Gloria Swanson was making one of her comebacks in *Father Takes a Wife*, eight years before her next, more successful one in *Sunset Boulevard*.

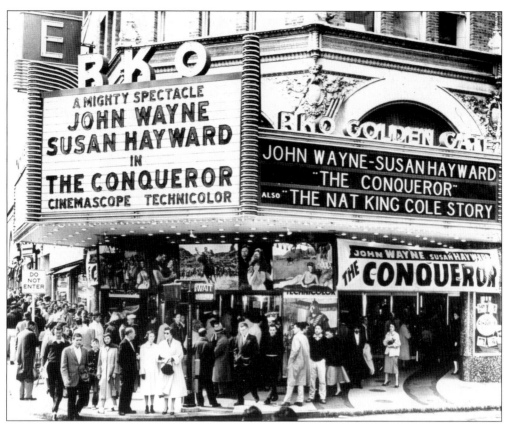

From this spring 1956 photograph, it is obvious that the concept of John Wayne as Genghis Khan had aroused the curiosity of moviegoers to an impressive extent. Judging from the movie's reputation, however, patrons probably left faster than they entered, so there was never a problem of selling out.

In the late 1960s, the Golden Gate was "twinned" into two separate theatres. The ill-conceived upstairs facility was renamed the Penthouse and is shown here offering a rerun of Ben Hur. The downstairs offered a single-strip version of 70-millimeter Cinerama, a far cry from the Orpheum's original three-strip presentation. Nevertheless, 2001: A Space Odyssey ran for 73 consecutive weeks in 1968–1969, and Fiddler on the Roof for 57 weeks in 1971–1972. After Man of La Mancha came and went in 1976, the Golden Gate's days as a downtown movie palace were over. It has now been restored to its former grandeur by the Shorenstein Hays Nederlander Organization and presents live shows.

Seven weeks after the opening of the Golden Gate, crowds greeted the Warfield at 982 Market Street. This theatre, still in use today for live performance, was built by Marcus Loew and named in honor of his actor friend David Warfield. The prolific G. Albert Lansburgh designed this one also, with an official seating capacity of 2,657. Together, the two new sites added no less than 5,500 seats to the intersection of Taylor and Market Streets in two short months.

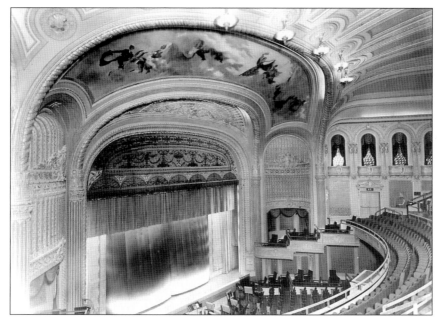

The interior of the Warfield, shown here as it originally looked, remains remarkably unchanged, from an architectural standpoint. Today, most of the main-floor seats are gone to accommodate comedy, pop, and rock concert spectators in a more contemporary manner. Although the entire building has been recently sold to an Atlanta developer, the theatre space is leased to Clear Channel Communications for the next two years, so its immediate future seems secure.

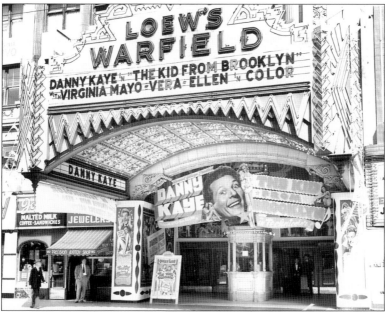

Life on Market Street was competitive, and each theatre seemed to be trying to outdo its neighbors with eye-catching displays. Here is a typical Warfield front from 1946 offering Danny Kaye in *The Kid from Brooklyn*. Each large theatre had its own sign shop in the basement whose full-time job it was to create these displays week after week using poster material supplied by the distributors and their own house pots of glitter and glue.

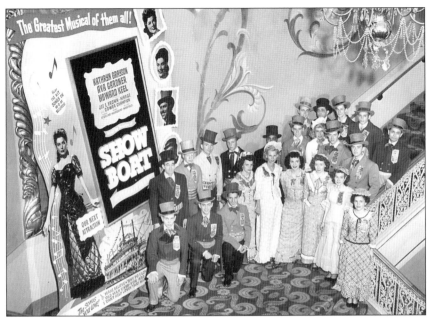

It was not unusual for Warfield staff members to be costumed in some style in tune with the current screen offering. For *Show Boat*, in 1951, all the cashiers, candy attendants, doormen, ushers, and usherettes appear like beached refugees from the original *Cotton Blossom* as they strike a pose on the balcony stairs. This once popular practice was phased out about the time of *Oh, Calcutta*.

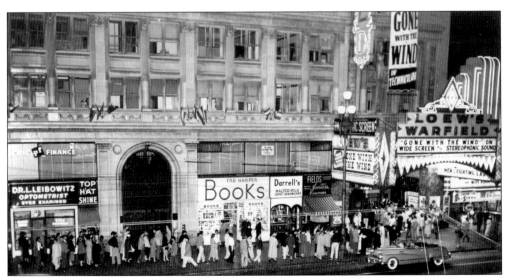

The 1954 wide-screen rerelease of *Gone with the Wind* brought large nighttime crowds to the Warfield Theatre.

Holding a near record for operating under the most different names, the Newsreel at 980 Market Street, next door to the Warfield, opened in 1909 as Lesser's Nickelodeon and is one of San Francisco's oldest and longest operating theatres. In 1910, showman Sid Grauman took it over for a short while before he moved on to the Empress in December 1910 and the greater and grander Imperial in December 1912. From 1912 to 1924, it was called the Biograph, then the Circle, then the Newsreel (1939–1949), then the Cinema, Crest, Egyptian, and Electric. Today it is the adult-themed Crazy Horse Gentlemen's Saloon.

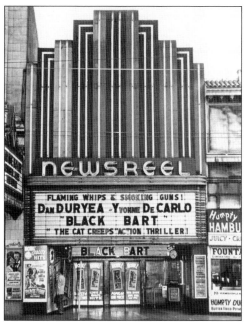

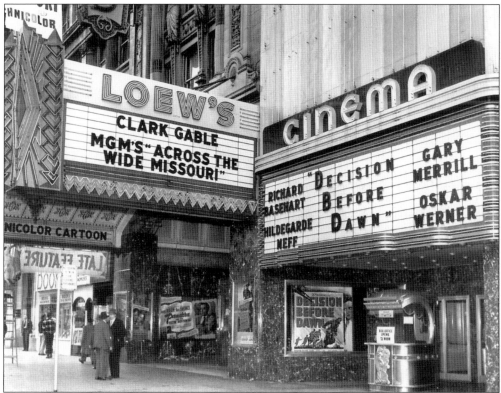

In the early 1950s, the Newsreel had been upgraded and called itself the Cinema, offering films that had previously premiered at the much larger Fox or Paramount. At the same time, the Warfield had once again become Loew's Warfield, after having been operated by Fox West Coast for many years.

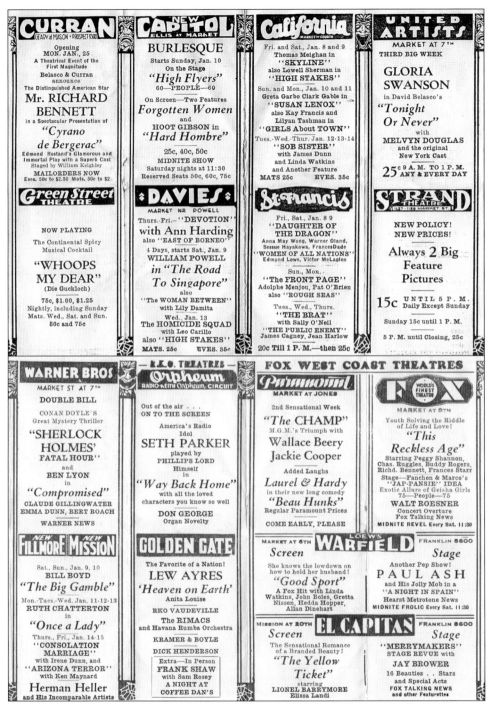

CURRAN GEARY at MASON · PROSPECT 9300

Opening
MON. JAN., 25
A Theatrical Event of the
First Magnitude
Belasco & Curran
announce
The Distinguished American Star
Mr. RICHARD
BENNETT
in a Spectacular Presentation of
*"Cyrano
de Bergerac"*
Edmond Rostand's Glamorous and
Immortal Play with a Superb Cast
Staged by William Keighley
MAILORDERS NOW
Eves. 50c to $2.50 Mats. 50c to $2

Green Street THEATRE

NOW PLAYING

The Continental Spicy
Musical Cocktail

"WHOOPS
MY DEAR"
(Die Guckloch)

75c, $1.00, $1.25
Nightly, including Sunday
Mats. Wed., Sat. and Sun.
50c and 75c

NEW CAPITOL ELLIS AT MARKET

BURLESQUE
Starts Sunday, Jan. 10
On the Stage
"High Flyers"
60—PEOPLE—60
On Screen—Two Features
Forgotten Women
and
HOOT GIBSON in
"Hard Hombre"
25c, 40c, 50c
MIDNITE SHOW
Saturday nights at 11:30
Reserved Seats 50c, 60c, 75c

DAVIES
MARKET NR POWELL

Thurs.-Fri.— "DEVOTION"
with Ann Harding
also "EAST OF BORNEO"
4 Days, starts Sat., Jan. 9
WILLIAM POWELL
*in "The Road
To Singapore"*
also
"The WOMAN BETWEEN"
with Lily Damita
Wed., Jan. 13
The HOMICIDE SQUAD
with Leo Carillo
also "HIGH STAKES"
MATS. 25c EVES. 35c

California MARKET AT FOURTH

Fri. and Sat., Jan. 8 and 9
Thomas Meighan in
"SKYLINE"
also Lowell Sherman in
"HIGH STAKES"
Sun. and Mon., Jan. 10 and 11
Greta Garbo Clark Gable in
"SUSAN LENOX"
also Kay Francis and
Lilyan Tashman in
"GIRLS About TOWN"
Tues.-Wed.-Thur. Jan. 12-13-14
"SOB SISTER"
with James Dunn
and Linda Watkins
and Another Feature
MATS 25c EVES. 35c

St Francis

Fri., Sat., Jan. 8 9
"DAUGHTER OF
THE DRAGON"
Anna May Wong, Warner Oland,
Sessue Hayakawa, FrancesDade
"WOMEN OF ALL NATIONS"
Edmund Lowe, Victor McLaglen
Sun., Mon.-
"THE FRONT PAGE"
Adolphe Menjou, Pat O'Brien
also "ROUGH SEAS"
Tues., Wed., Thurs.
"THE BRAT"
with Sally O'Neil
"THE PUBLIC ENEMY"
James Cagney, Jean Harlow
20c Till 1 P. M.—then 25c

UNITED ARTISTS MARKET AT 7TH

THIRD BIG WEEK

GLORIA
SWANSON
in David Belasco's
*"Tonight
Or Never"*
with
MELVYN DOUGLAS
and the original
New York Cast
25c 9 A. M. TO 1 P. M.
ANY & EVERY DAY

STRAND THEATRE 1127-1129 MARKET ST.

NEW POLICY!
NEW PRICES!

Always 2 Big
Feature
Pictures

15c UNTIL 5 P. M.
Daily Except Sunday

Sunday 15c until 1 P. M.

5 P. M. until Closing, 25c

WARNER BROS MARKET ST AT 7TH

DOUBLE BILL

CONAN DOYLE'S
Great Mystery Thriller
"SHERLOCK
HOLMES'
FATAL HOUR"
and
BEN LYON
in
"Compromised"
CLAUDE GILLINGWATER
EMMA DUNN, BERT ROACH
WARNER NEWS

NEW FILLMORE NEW MISSION

Sat., Sun., Jan. 9, 10
BILL BOYD
"The Big Gamble"
Mon.-Tues.-Wed. Jan. 11-12-13
RUTH CHATTERTON
in
"Once a Lady"
Thurs., Fri., Jan. 14-15
"CONSOLATION
MARRIAGE"
with Irene Dunn, and
"ARIZONA TERROR"
with Ken Maynard
Herman Heller
and His Incomparable Artists

R.K.O. THEATRES — Orpheum RADIO-KEITH-Orpheum CIRCUIT

Out of the air . . .
ON TO THE SCREEN

America's Radio
Idol
SETH PARKER
played by
PHILLIPS LORD
Himself
in
"Way Back Home"
with all the loved
characters you know so well

DON GEORGE
Organ Novelty

GOLDEN GATE

The Favorite of a Nation!
LEW AYRES
'Heaven on Earth'
Anita Louise
RKO VAUDEVILLE
The RIMACS
and Havana Rumba Orchestra
KRAMER & BOYLE
DICK HENDERSON
Extra—In Person
FRANK SHAW
with Sam Rosey
A NIGHT AT
COFFEE DAN'S

FOX WEST COAST THEATRES

Paramount MARKET AT JONES

2nd Sensational Week
"The CHAMP"
M.G.M.'s Triumph with
Wallace Beery
Jackie Cooper
Added Laughs
Laurel & Hardy
in their new long comedy
"Beau Hunks"
Regular Paramount Prices
COME EARLY, PLEASE

MARKET AT 6TH **LOEW'S WARFIELD** FRANKLIN 8600
Screen Stage
She knows the lowdown on Another Pep Show!
how to hold her husband! PAUL ASH
"Good Sport" and His Jolly Mob in
A Fox Hit with Linda "A NIGHT IN SPAIN"
Watkins, John Boles, Gretta Hearst Metrotone News
Nissen, Hedda Hopper, MIDNITE FROLIC Every Sat. 11:30
Allan Dinehart

MISSION AT 20TH **EL CAPITAN** FRANKLIN 8600
Screen Stage
The Sensational Romance "MERRYMAKERS"
of a Branded Beauty! STAGE REVUE with
*"The Yellow JAY BROWER
Ticket"* 16 Beauties . . Stars
starring and Special Acts
LIONEL BARRYMORE FOX TALKING NEWS
Elissa Landi and other Featurettes

FOX WORLD'S FINEST THEATRE MARKET AT 9TH

Youth Solving the Riddle
of Life and Love!
*"This
Reckless Age"*
Starring Peggy Shannon,
Chas. Ruggles, Buddy Rogers,
Richd. Bennett, Frances Starr
Stage—Fanchon & Marco's
"JAP-PANSIE" IDEA
Exotic Allure of Geisha Girls
75—People—75
WALT ROESNER
Concert Overture
Fox Talking News
MIDNITE REVEL Every Sat. 11:30

The two-sided, 16-page, accordion-style Official Amusement Guide was a free weekly fixture on the front desks of downtown hotels, restaurants, and anywhere else that the entertainment-seeking public might congregate, tourists and locals alike. The issue shown here is for the week of January 7, 1932. All of the theatres are offering either first-run films or live attractions, except for El Capitan and New Fillmore/New Mission, which were prestige second-run neighborhood

houses. Warner Brothers was the Embassy, operating under that name for a few years in the early 1930s. Meanwhile, the Davies became the Esquire, the Community Playhouse became Marine's Memorial, and Dreamland became Winterland. Note the ticket prices at the Strand—even Richard Bennett in person in *Cyrano de Bergerac* at the Curran commanded only $2.50 tops, 50¢ for the balcony.

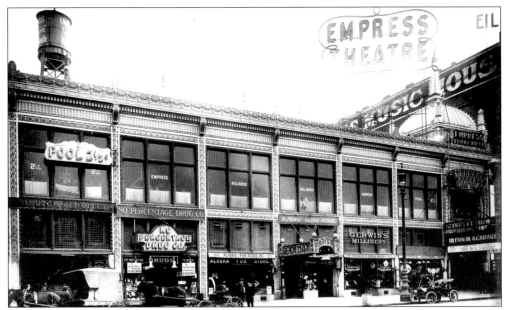

The St. Francis at 965 Market Street, designed by John Galen Howard, opened December 4, 1910 as the Empress with 1,455 seats, making it the largest Market Street theatre to date. Yet it was small in comparison to those that followed. Vaudeville was the big attraction at first (it was initially operated by Sid Grauman, Sullivan and Considine) then gradually movies took over. It was renamed the Strand in 1917 (not to be confused with the better known Strand at 1127 Market Street) and rechristened St. Francis in 1925.

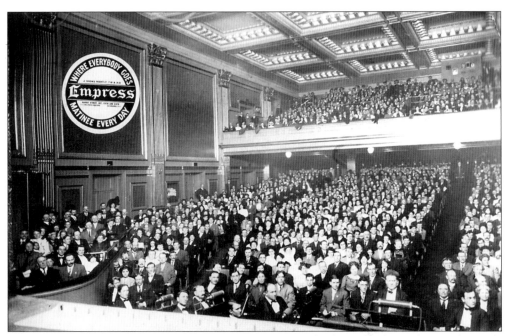

The capacity crowd shown here are unaware that they had achieved immortality in this early Empress postcard photograph.

The newly renamed St. Francis boasts a variety of signs in August 1925, as D. W. Griffith's *Sally of the Sawdust* heralds its contribution to Greater Movie Season. The dual marquee seems a little redundant, and the roof sign tells it all over again. Counting the front, both sides, and the roof, the name "St. Francis" appears no less than seven times.

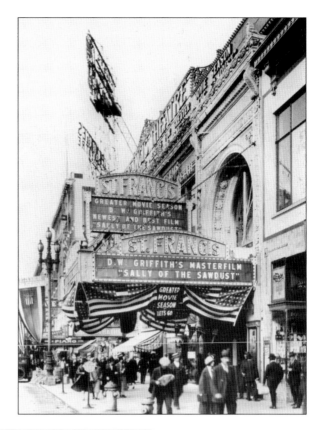

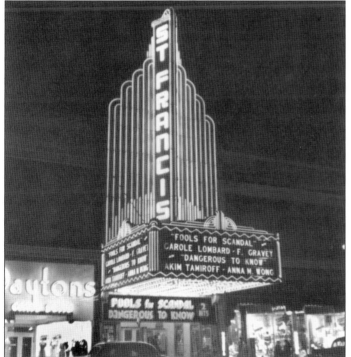

By 1938, the St. Francis had toned things down to a more tasteful moderne style but was still making the most of its narrow Market Street frontage.

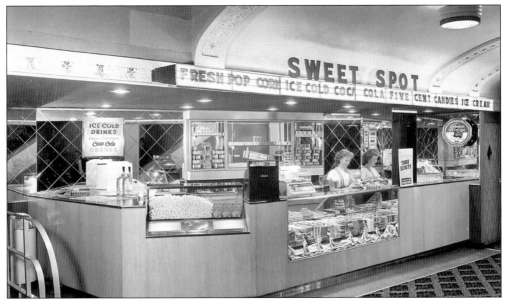

Snack bars were a post–World War II phenomenon. The St. Francis "Sweet Spot" (seen here in 1950) seems modest by today's standards but did the job in its own polite way.

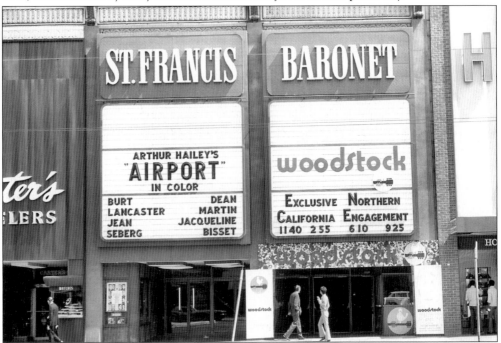

In the late 1960s, the St. Francis was successfully twinned into upstairs and downstairs auditoriums, the top half being labeled the Baronet. In the mid-1970s, the arrangement was simplified as the St. Francis I and II. Now in the heart of the Market Street "war zone," it hung on until the end of October 2000, when it quietly shut down. Despite the fact that it had served moviegoers for just a few weeks short of 90 years and was the last theatre on Market Street to offer mainstream film fare (the Strand, by this time was serving up video pornography), not a single paragraph appeared in the *San Francisco Chronicle* to document its demise.

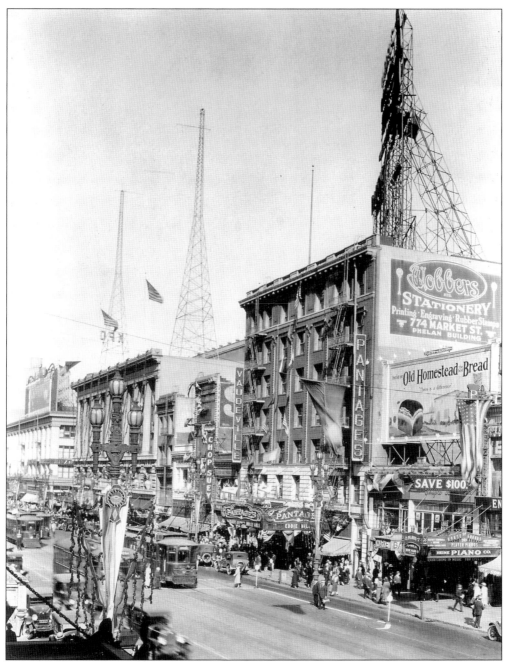

The Pantages opened on December 30, 1911, at 937 Market Street a little over a year after its neighbor a few doors to the West, the St. Francis (formerly Empress). This was architect B. Marcus Priteca and entrepreneur Alexander Pantages's first combined effort and led the way for many theatres to follow in a similar "Pantages" style. For the next decade and a half, it offered only live vaudeville. It closed in February 1926, when the Pantages name moved up the street to his newly built site at Market and Hyde Streets, known today as the Orpheum. In later years, Kress Department Store occupied the building, which still stands today as a commercial outlet.

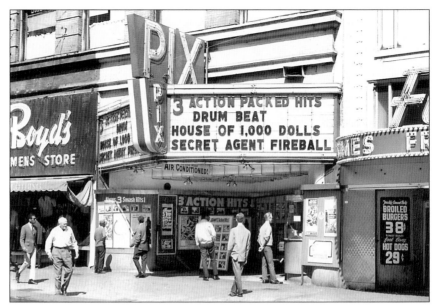

The Pix, east of Mason Street at 938 Market Street (1946–1972), was the street's youngest theatre, the only one to be opened after the end of World War II and also the smallest (a mere 280 seats). Although ostensibly just another grind house, it did offer one unique perk all its own—it was air conditioned! So on a hot September night, while the overdressed were sweltering in the non–air conditioned Opera House, moviegoers could enjoy three "Action Packed Hits" (plus six color cartoons) for just 50¢ in the cool comfort of the Pix. Today it is a Radio Shack.

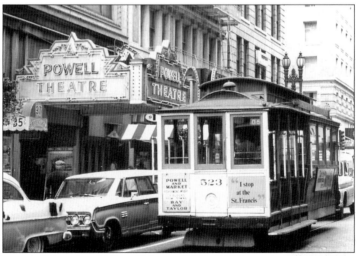

The Powell (formerly Edison) at 39 Powell Street (1911–1977) wasn't on Market Street proper, but it was close enough to be included here. Offering more polite programming than its brothers down the street (more romance and music, less action), the Powell remained remarkably unchanged over the years. Stepping into the Powell was like going into a time machine—the tapestries on the walls had to have gone back to its Edison days. And even though it wasn't a revival house in the true sense of the word, Greta Garbo or Jeanette MacDonald were almost as likely to pop up on the Powell's 1950s and 1960s schedules as Elizabeth Taylor or Doris Day. In the late 1960s, while other theatres were showing the Franco Zeffirelli version of *Romeo and Juliet*, the Powell still ran the 1936 version with Norma Shearer. Today it is a Burger King.

The Esquire opened in 1909 at 934 Market Street as the Market Street Theatre; in later years, it was renamed Alhambra, Frolic, Cameo, Marion Davies, and finally Esquire in 1940. Operated by Blumenfeld Theatres Inc. in conjunction with their United Artists and Orpheum, the Esquire became the 1940s' first-run home of all the Universal Pictures pop heroes, heroines and horrors, from Abbott and Costello to Maria Montez to Frankenstein, Dracula, the Wolf Man, the Mummy, and all their sundry relatives. Often, overflow crowds were shuttled through the back door to the Tivoli on Eddy Street (also operated by Blumenfeld) that quite conveniently was playing the same program. In the early 1970s, under the auspices of Syufy Enterprises, it became an outlet for American International Pictures's biker and horror flicks. It closed in 1972 and was immediately torn down to make way for BART and Halladie Plaza.

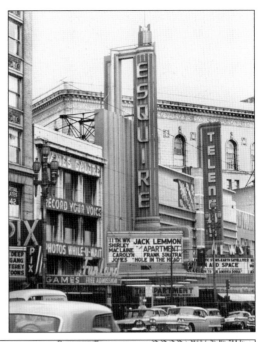

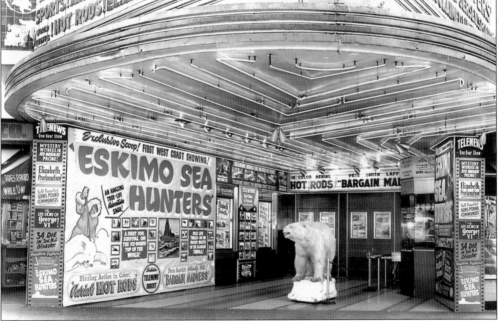

The Telenews opened in 1939 at 930 Market and was the first theatre in San Francisco to offer a "streamlined" one-hour program of newsreels and documentary short features. During World War II, theatres like Telenews were in the heart of every metropolitan area, offering an up-to-date look at wartime developments as well as other world events. In later years, eye-grabbing lobby displays like this one got the attention of passersby, who would drop in on the spur of the moment, happily willing to spend half a dollar to see what all the excitement was about. Telenews preceded its next door neighbor, the Esquire, into history in 1967, when it closed and was torn down so that work could begin on the Powell Street BART Station and Halladie Plaza.

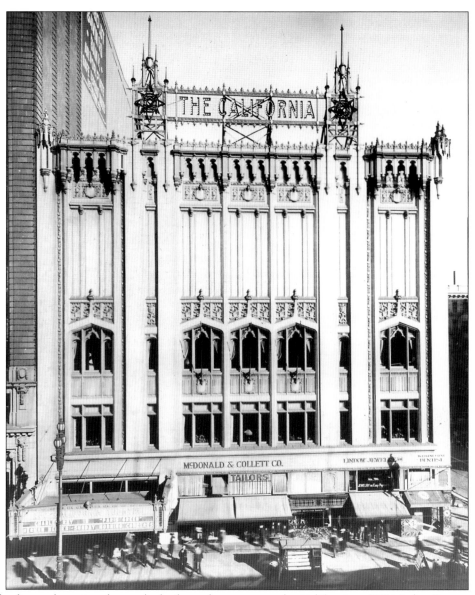

The first real movie palace to be built on the street was the California at 987 Market Street, on the southeast corner of Market and Fourth Streets. Designed in Gothic style by Alfred Henry Jacobs, it opened on November 1, 1917, and was a true "Cathedral of Motion Pictures," with 2,135 seats, 60 percent of them in the balcony. Its early popularity proved to be short lived, however, as more and more theatres continued to be built further to the west, so the California was stranded in a location that was just a little too far outside the theatre "district." After struggling through the Depression, it was given a fresh front, renamed the State, and reopened on New Years Eve 1941, but its luck failed to improve. Offering revivals, often of films that really didn't deserve to be revived, extended second-runs from the Paramount, and occasional first-runs of poor-quality films, it finally shut down in March 1954. For the next few years it stood vacant, only occasionally dusting off the seats for religious services. Poignantly, the marquee was used to promote whatever was showing at the St. Francis up the street. In 1961, it was finally torn down, and Roos-Atkins clothing store built in its place.

During its peak in the early 1920s, the California's vast interior housed a 4-manual, 32-rank Wurlitzer organ, one of the largest ever built by that firm. It also offered Sunday morning classical concerts, and for a two-week period in 1922, famous composer Victor Herbert conducted the orchestra.

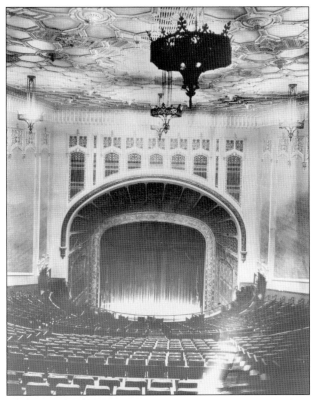

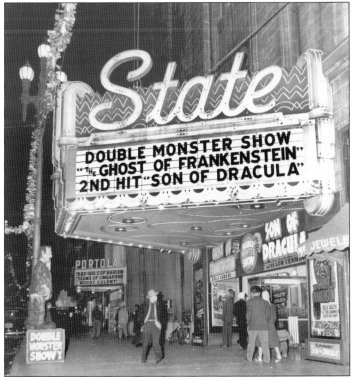

In December 1948, a papier-mâché likeness of the Frankenstein monster directs potential ticket-buyers to the State Theatre box office for a revival double bill of *Ghost of Frankenstein* and *Son of Dracula*. Problem was both films were over five years old by that time and were only secondary entries in the series to begin with. This was not the sort of stuff to fill up 2,000 empty seats! Note the Portola next door, showing *Bad Girls of Harlem, Slums of Singapore*, and *Nudist Colony*.

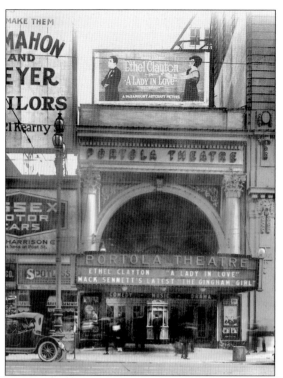

The Portola at 779 Market Street opened in September 1909 in conjunction with the Portola Festival, held in October of that year. It was one of Market Street's first major film houses for its first 10 years, but it soon lost ground to the magnificent California, a short walk to the west. This 1920 photograph offers a view of the Portola's brave attempt at grandeur on a much smaller scale, but it was a lost cause. A false front wasn't enough; the Portola closed in 1928 and became a Gray Line Bus Terminal. Surprisingly, it rose from the ashes and reopened in 1944, catering to the ever-present wartime crowds that now surged up and down Market Street. Soon the Portola came alive again and began to thrive on the type of cutting-edge exploitation fare that could not be found in conventional houses. It was renamed the Paris in 1961 and lasted another 10 years until it finally fell to the wrecker's ball in 1971 in the name of redevelopment.

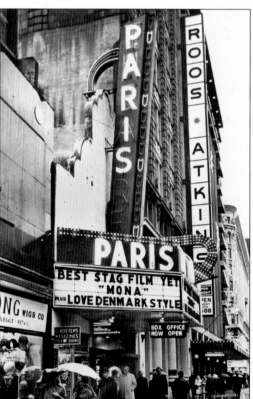

In this 1971 image, the California—torn down 10 years earlier—has been replaced by Roos Atkins, but the Portola (by now the Paris) survives. But not for much longer. *Mona* was a big success in the adult genre, but what exactly *Love Denmark Style* was even the Internet Movie Database doesn't seem to know.

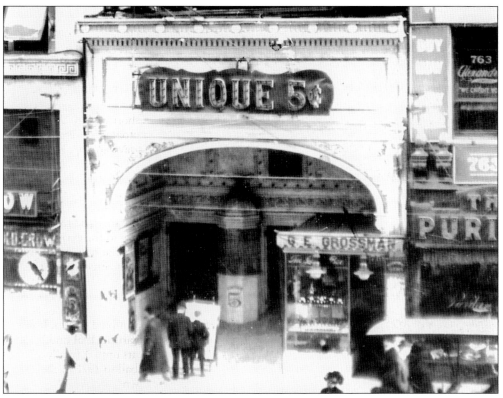

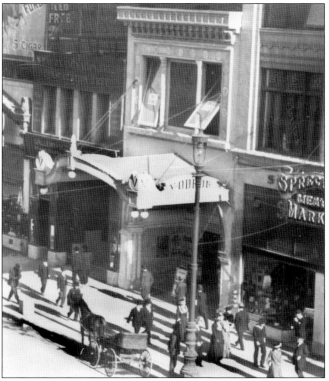

The Unique, also known as Wonderland, 757 Market Street, was typical of the countless nickelodeon-style enterprises that sprung up in the formative years of motion pictures. It operated from 1909 to 1934 and then quietly disappeared.

Built on the site of the former Cineograph at 747 Market Street, the Odeon prospered from 1914 to 1924, then shut down and became the Metropolitan Market.

The Silver Palace (1908–1972) at 727 Market Street, opposite Grant Avenue, was the easternmost theatre on Market Street, the fifth in a single block (the south side of Market between Third and Fourth Street) and one of the street's oldest. Its grind policy pretty much duplicated the type of programming found at its sister theatres, the Regal and the South of Market Peerless, with four changes of program each week and two features on every bill (expanded to three in the 1950s). It was renamed the Hub in 1951, closed in 1972, and has since been converted into retail space.

The Peerless (1912–1970) at 148 Third Street, between Mission and Howard Streets, is included here with the Market Street group because, for the greater part of its existence, it was owned and operated by Aaron Goldberg, who also ran the Regal, Silver Palace, and the Newsreel. These houses were known as the Little Downtown Theatres, all with identical grind-house schedules. Built at a time when South of Market had its share of family residences, the Peerless suffered as the neighborhood deteriorated into Skid Row in the 1930s and 1940s, became a haven for derelicts, and was an early convert into the pornography revolution of the early 1960s. It offered "Nude-O-Rama" and other fare (note Roxy News Company next door) and survived until redevelopment leveled the block in 1970.

Two

LIVE THEATRE

The popularity of live entertainment in San Francisco is unquestionable. The major venues have been around for a long, long time and continue to thrive. In the meantime, countless other locations, large and small, have come and gone over the years and are now totally forgotten. The variety of what is offered is only limited by the imaginations of the entrepreneurs, and the survival of the site usually depends on how much (or how little) the managers are in tune with what the public is buying this week, this month, this year. Interestingly, 30 years became the standard of acceptance here in several cases. There is nothing like the test of time, and readers may find some surprising inclusions that not only add flavor to the stew but accurately reflect both the diversity of San Francisco taste and the loyalty of its citizenry to shows that have long since become part of the family. Sadly, the limitations of space have forced the omission of several interesting and important sites that have also been around a long time, but many have already been covered in depth in Dean Goodman's well-researched *San Francisco Stages*, published in 1986.

For reasons unknown, live venues were built and developed on streets branching westward from the north side of Market (such as on Geary, O'Farrell, Ellis, Eddy, and McAllister Streets), whereas the theatres on Market Street itself were all film houses (with the single exception of the original Pantages, which closed in 1926). Of course, many of the north of Market legit sites went into film in the 1930s but none of them for very long or very successfully. Today the Geary and Curran carry on the old tradition, while former film emporiums on Market such as the Orpheum, Golden Gate, Warfield, and United Artists have now gone live as well.

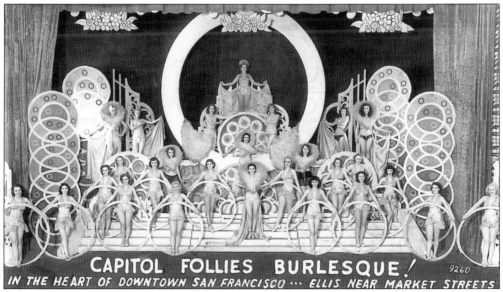

CAPITOL FOLLIES BURLESQUE!
IN THE HEART OF DOWNTOWN SAN FRANCISCO ··· ELLIS NEAR MARKET STREETS

Seventy years ago, the Capitol Theatre, having given up on conventional stage shows and film entertainment, survived the Depression when Chicagoan Eddie Skolak brought live burlesque to downtown San Francisco. Tame by today's standards but just spicy enough to crank up the metabolism of our grandfathers, the Capitol Follies bumped and ground its way along until 1941, when burlesque, far from dead, moved up to McAllister Street, where it held court at the President for the next 20 years.

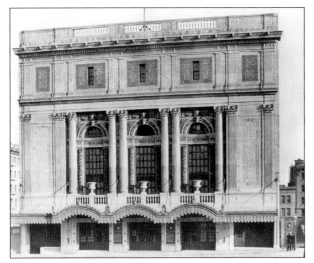

In terms of age and importance, the Geary at 425 Geary Street is the reigning monarch of San Francisco theatres. Built by Bliss & Faville for Gottlob and Marx in 1909, the Geary opened as the Columbia on January 10, 1910, with 1,450 seats and was renamed the Geary in the mid-1920s, during which time it also operated as the Lurie. Although primarily the home of legitimate drama, the Geary occasionally condescended to show motion pictures of "distinction and merit" such as Cecil B. De Mille's *The Ten Commandments*, Walt Disney's *Fantasia*, and Orson Welles' *Citizen Kane*, and the unfortunate *Mourning Becomes Electra*. Since the late 1960s, it has been the home of the American Conservatory Theatre. Despite suffering debilitating damage as a result of the October 1989 Loma Prieta earthquake, a few years and a few million dollars later, it was restored it to its former grandeur.

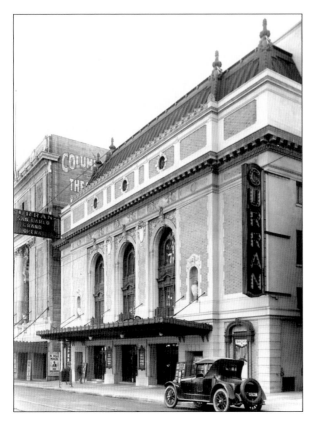

The Curran Theatre at 455 Geary Street was designed by Alfred Henry Jacobs for Homer Curran, built at a cost of $800,000, and opened September 10, 1922. Like its next-door neighbor, the Curran has always been home to live theatre, except for a single foray into the world of celluloid with its 1925 presentation of *The Phantom of the Opera*. In this shot, it is offering the *San Carlo Grand Opera*; note that the Geary next door was still called the Columbia.

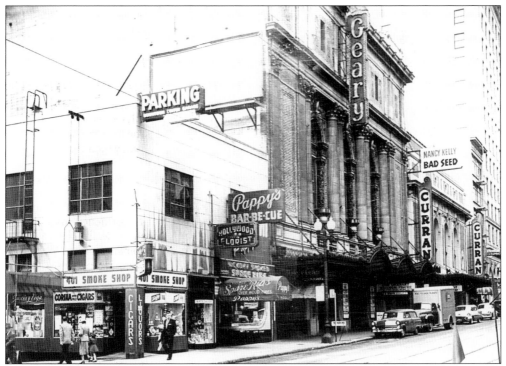

Here is Geary Street in the mid-1950s. The corner Smoke Shop, Hollywood Florist, and Pappy's Bar-Be-Cue are all history now, as are the streetcar tracks and eastbound automobile traffic. Yet the Geary and Curran stand, minus one or two vertical signs, but otherwise looking just about the same today as they did when this picture was taken 50 years ago.

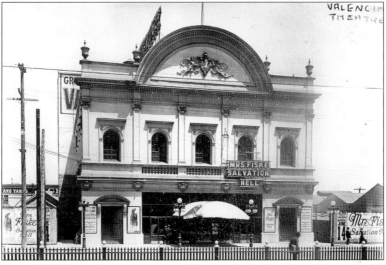

The Valencia at 235 Valencia Street, between Thirteenth (Duboce) and Fourteenth Streets, was designed by J. Charles Green, and opened September 12, 1908. The location was a bad choice, and the business was never successful. In the mid-1920s, it ended its life as a theatrical enterprise but continued to serve the community for the next 45 years as the St. Sophia Greek Orthodox Cathedral. It was torn down after being severely damaged by the Loma Prieta earthquake of October 1989.

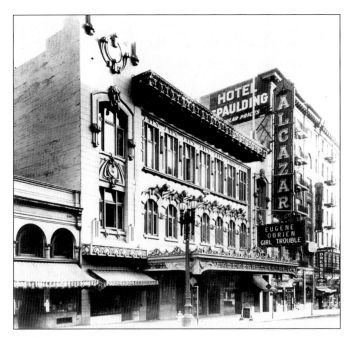

San Francisco's third Alcazar Theatre, located at 260 O'Farrell Street, was designed by Cunningham and Polito and built on the site of the first Alcazar, which was destroyed in the 1906 earthquake. It opened on December 23, 1911, and was operated at various times by the Belascos, Thomas Wilkes, and Henry Duffy (who at one time had eight playhouses on the West Coast). In the late 1930s, it headquartered the Federal Theatre Project of the Works Progress Administration (WPA).

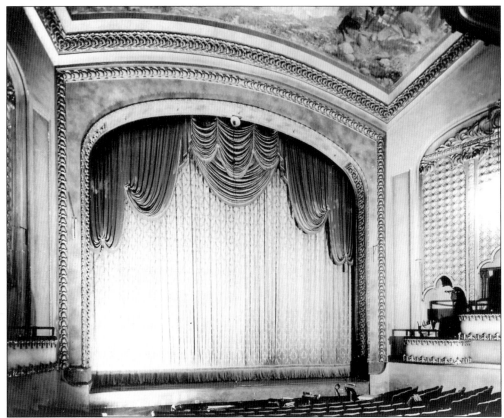

The attractive interior and comfortable size (1,145 seats) of the Alcazar were just the right combination of extravagance and practicality to make it a popular venue for stage presentations.

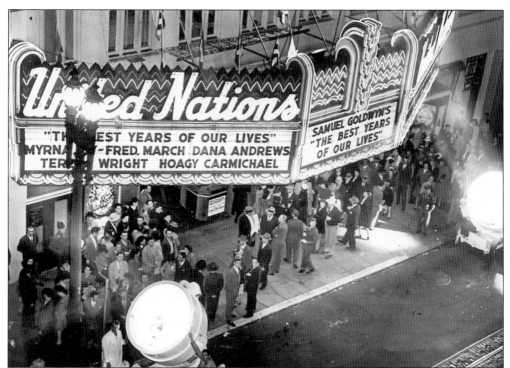

After being used for several United Nations peace conferences (headquartered at the Opera House) in 1945, the Alcazar was renamed the United Nations and reopened by Fox West Coast as a first-run prestige film house. However, as it was off the beaten Market Street film track, it failed to click and shut down after only a few years.

On July 8, 1952, Alcazar reopened under its original name and once again became a popular legit house under the management of Randolph Hale, whose wife Marjorie Lord starred for several months in the comedy favorite *Anniversary Waltz*. Tours were arranged with the New York Theatre Guild and the names of big name stars became the norm on its marquee. Its final production was *Rhinoceros* starring Zero Mostel. The theatre closed on December 31, 1961, and was torn down. The Handlery Hotel now stands in its place.

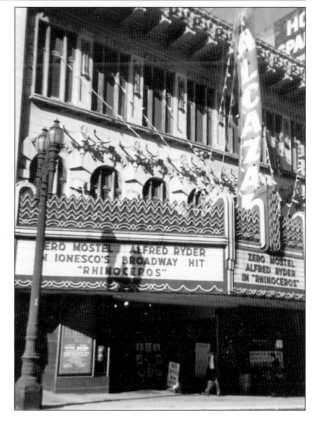

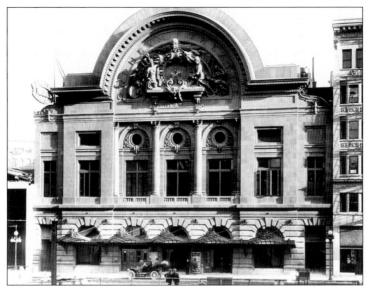

The Orpheum Theatre at 147 O'Farrell Street was built on the site of the previous Orpheum that had been destroyed by the earthquake of 1906. It was architect G. Albert Lansburgh's first theatre project and opened on April 19, 1909, with seating for 2,300. In between the two O'Farrell Street structures, two other theatres had borne the Orpheum name: the Chutes Theatre on Fulton Street in 1906 and the Orpheum/Garrick on Ellis Street in 1907. After the new Pantages Theatre on Market Street was renamed the Orpheum in 1929, this one became the Columbia, lifting the name from the Geary Street site, which had now become the Geary. The Orpheum was strictly vaudeville, so the double whammy of the introduction of sound motion pictures combined with the stock market crash of October 1929 and the ensuing economic depression were death-dealing blows from which it never recovered. It closed in 1937 and was torn down in 1938. A garage now occupies the site.

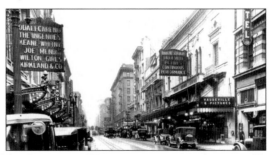

In 1913, the Essanay Film Company's Western unit was cranking out films in Niles, California, and its star, Broncho Billy Anderson, was riding the crest of his popularity and income. He purchased some land at 160 O'Farrell Street, just west of Stockton Street and across the street from the Orpheum, for $375,000 and, with high hopes, sunk another $150,000 into construction of what he was to call the Gaiety Theatre. It opened on October 18, 1913, and, despite getting off to a promising start, proved to be a doomed financial venture. Only a year and a half after it opened, Anderson turned the management of the Gaiety over to Ackerman and Harris who renamed it the Hippodrome. Ten years later it became the Union Square, offering a combination of vaudeville and films. Talkies and the Depression hit it just as hard as its bigger cousin across the street, and by the early 1930s, it was struggling to stay alive as the Filmarte. It closed in 1933 and was torn down in 1936 to make way for the expansion of O'Connor, Moffatt & Company's department store (now Macy's).

Like the American/Embassy, the President, as the Colonial at 80 McAllister Street, was under construction at the time of the 1906 earthquake and fire, with "1905" already prominently embedded over the facade, but there is no record of it actually having opened yet. It officially opened on October 6, 1906, and was later renamed the Savoy, Oriental, and finally President in 1925. Like the Alcazar, it was one of Henry Duffy's popular West Coast playhouses. Unfortunately it also fell victim to talkies and the Depression in the early 1930s.

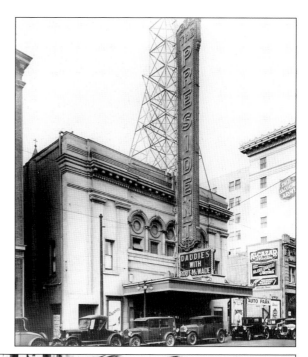

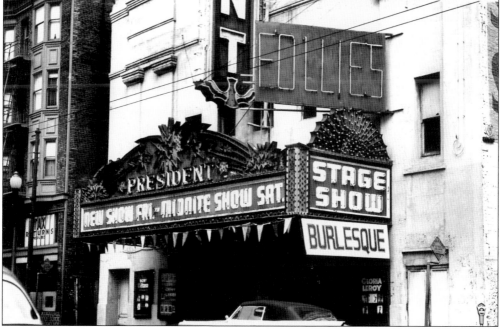

After the closure of the Capitol, the President, under Eddie Skolak's guidance, took over the reins as San Francisco's leading burlesque house, calling itself the President Follies, combining mainstream movies with live entertainment. After more than two successful decades, the President had become the last burlesque house on the West Coast, but in September 1963, the strippers peeled for the last time. The doors closed, and the theatre was torn down. A senior citizen facility now stands on the site. During this time, the G-String Brigade moved on to the former Victoria on Sixteenth Street, renamed the New Follies, and the show went on for a few more years.

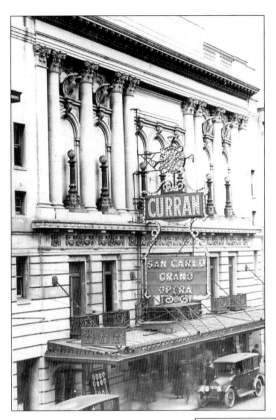

The Capitol at 64 Ellis Street opened on September 2, 1911, as the Cort, operated by John Cort. After offering the first performance of the new San Francisco Symphony on December 18 of that year, it became their headquarters. From 1918 to 1921, it operated as the Curran by Cort's former manager Herman Curran, then as the Century, the Morosco, and in 1923 was renamed the Capitol. With nearly 3,000 seats, it rivaled the size of San Francisco's largest, but its out-of-the-way location was more a hindrance than a help. In this photograph, the San Carlo Opera is making a pit stop; afterwards they would choose the better location of the newer Herman Curran venture on Geary Street.

So how depressed could the Depression get? If "3 BIG HITS" for "15¢ ANY TIME" is any indication, that's pretty grim even by 1932 standards. Live burlesque pulled the Capitol out of the doldrums in the late 1930s, but there were just too many unfilled seats to make it worthwhile. It closed in 1941 and was torn down.

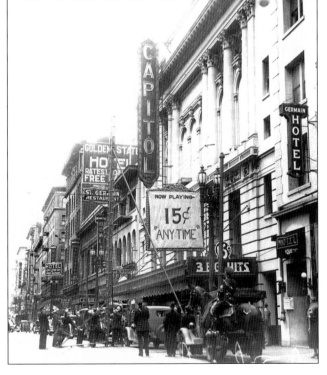

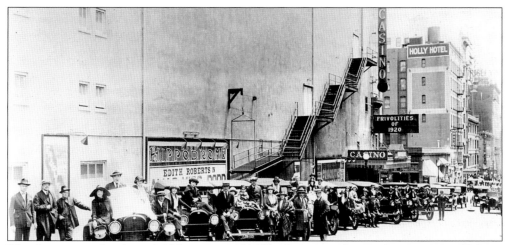

The Casino, another huge 2,000-seater at 198 Ellis Street, on the northeast corner of Mason Street, opened April 8, 1917 with vaudeville. Here the *Frivolities of 1920* cast, crew, and motorcade pose for posterity. The Hippodrome billboard is for its nearby neighbor, the renamed Gaiety on O'Farrell Street.

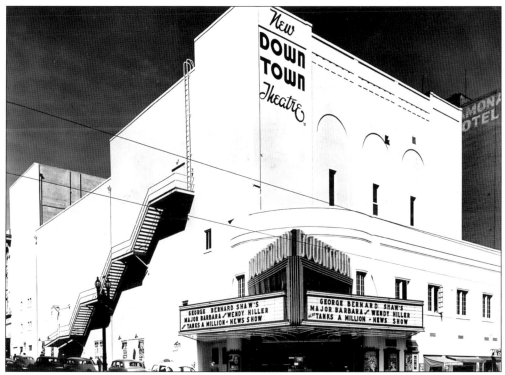

On January 1, 1942, the former Casino, with an up-to-date marquee, reopened as the Downtown, offering low price, late-run and rerun films plus Spin-O-Win, with a change of program every day. During the next 10 years, this policy kept the wolf from the door, with occasional less-than-successful ventures into reviving live vaudeville, but by 1952, the handwriting was on the wall. Television was here to stay and was offering more or less the same thing on home screens. So another dinosaur of the past closed its doors and was torn down. Today it is the site of the Nikko Hotel.

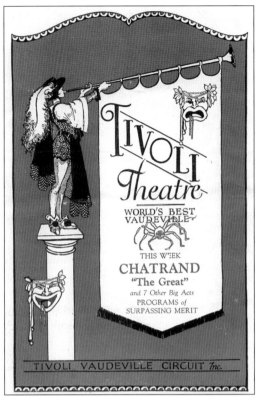

Chatrand the Great, a mind-reading act, headlines the Tivoli's vaudeville show. Inside the program we learn that other acts include "Mack and Larue, skating marvels of the century," "Jack and Ted Dale, the Chocolate Cake Eaters," "Myrtle and Ivy in A Little Bit of Everything," "Ethel Cantor, the Hurrah Girl, in a Budget of original songs and dances," and "Rita, the celebrated Spanish dancer, with her own company of internationally celebrated coryphées, assisted by the Manila Marimba Band."

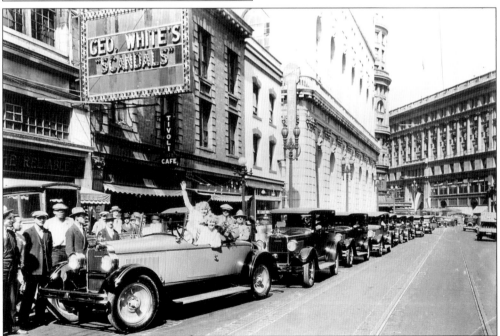

On a rosier note, the Duncan sisters, Vivian and Rosetta, big names in vaudeville, and particular favorites here in San Francisco, arrive at the Tivoli prior to their appearance in *George White's Scandals* in a sporty late-1920s Packard roadster.

San Francisco's first Tivoli was a beer garden on Eddy Street that opened in 1875 and was renamed Tivoli Opera House in 1879. It closed in 1903 and was replaced by the bigger and better Tivoli on the southwest corner of Eddy and Mason Streets in December 1903. This is one recreated by MGM in 1936 for their film *San Francisco*, starring Jeanette MacDonald; it was destroyed in 1906. The third Tivoli opened on March 12, 1913, at 74 Eddy Street, approximately on the site of the first one, but after nearly 10 years, the name had begun to fade, the location had lost its luster, and it was never able to achieve the popularity of its predecessors. In its last days it once again attempted vaudeville, but that failed too. It closed in 1949, and was eventually torn down.

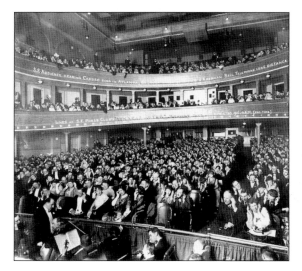

At 4:00 a.m. on April 30, 1916, a near-capacity audience at the Tivoli listened to Enrico Caruso sing in Atlanta, Georgia, over Pacific and American Bell Telephone long-distance lines at the San Francisco Press Club's "Ten Years After" commemoration of the 1906 earthquake and fire. Caruso had been appearing in San Francisco at the time of the quake and vowed never to return. Holding true to his promise, this is apparently the closest he would come. Why the event was scheduled for the morning of April 30th, instead of the fateful day of April 18th is not clear. Note the Tivoli's "dress circle" topped by not one, but two balconies.

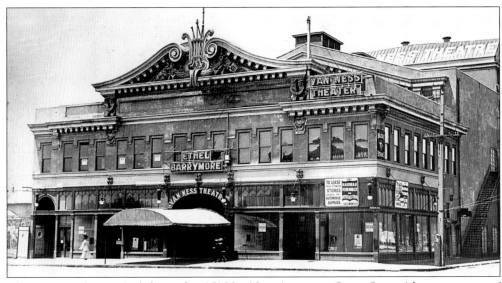

The Van Ness (1907–1910), located at 259 Van Ness Avenue at Grove Street (the present site of Louise M. Davies Hall), was a short-lived operation. It was a somewhat grotesque structure that soon fell to the wrecking ball after final performances in the summer of 1910. Initially operated by Gottlob and Marx, who moved on to a much better site on Geary Street when the Columbia opened in January 1910, the impermanence of the Van Ness building and the inappropriateness of the location soon brought about an end to its brief life. It was razed and disappeared from sight after only three years.

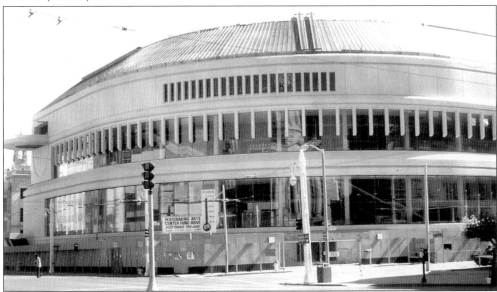

At 201 Van Ness Avenue, at the southwest corner of Van Ness and Grove Street (former site of the short-lived Van Ness Theatre), stands Louise M. Davies Hall, which was built at a cost of $28 million ($10 million of it state and federal funding) on land donated by the City of San Francisco. Completed in September 1980, it owes its name to the efforts and perseverance of the largest individual contributor to its completion, Louise M. Davies. After 12 years of mixed reviews, it underwent major upgrading and renovation in the summer of 1992 and is presently the home of the San Francisco Symphony, under the direction of Michael Tilson Thomas.

The Liberty, situated at 649 Broadway and directly across the street from the Verdi, opened in 1909 as the California, but was renamed Liberty the following year. During the 1940s, it prospered by combining live burlesque on the stage with exploitation films (of the *Reefer Madness* variety) on the screen. In 1949, that was all put aside, and it reopened as the World, offering international films. It closed in 1953, was torn down, and a motel built on the site. Meantime the name "World" moved across the street to the former Verdi, where it remained until 1983.

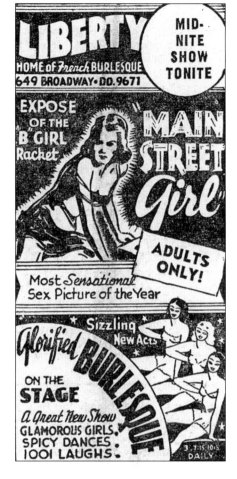

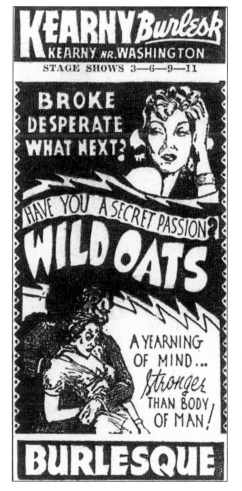

The Kearny at 825 Kearny Street had opened in 1911 as the Shanghai, offering live Chinese theatre, but was soon renamed the Kearny. During World War II, it offered what seemed to be an exact copy of the florid packaging of stage and screen entertainment found at its sister theatre, the Liberty, but rumor had it that its performers were sent to the Kearny after the bloom was off the rose and their mileage was beginning to show.

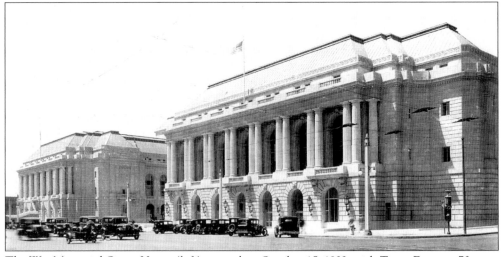

The War Memorial Opera House (left) opened on October 15, 1932, with *Tosca*. For over 70 years it has commanded two blocks of Van Ness Avenue, from Grove Street to McAllister Street, along with its twin, the Veterans Building, which now houses the Herbst Theatre (right). Designed by Arthur Brown Jr., who also built San Francisco's city hall and Coit Tower, the Opera House, with 3,146 seats, is the home of the San Francisco Opera and San Francisco Ballet. The Herbst, on whose stage the United Nations Charter was signed on June 26, 1945, offers musical recitals, lectures, and dramatic presentations of a less extravagant nature. Another victim of the October 1989 Loma Prieta earthquake, the landmark Opera House shut down for 18 months while it underwent a $50 million retrofit along with a $28 million overall upgrading.

The Civic Auditorium at 99 Grove Street was constructed in 1914 by the Panama-Pacific International Exposition and later presented to the municipality as the exposition's permanent legacy. Its versatility is reflected by its variety of names—originally it was called Exposition Auditorium, later Civic Auditorium, and now Bill Graham Civic Auditorium. Initially boasting accommodations for 12,000, it now provides 4,177 seats. For over 90 years, it has provided space to every kind of show, high school graduation, dog show, circus, and rock and rap concerts.

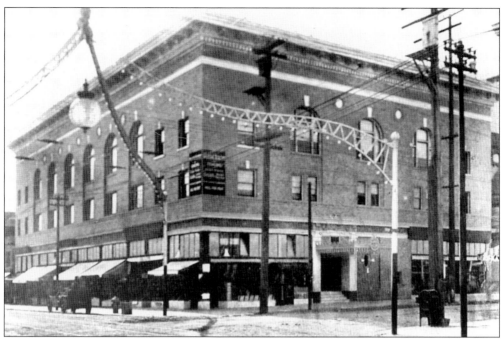

When the Majestic Hall at 1805 Geary Street (at the southwest corner of Fillmore Street) opened in 1912, Wednesday night socials and masquerade balls were the typical bill of fare. In later years, it was a dance hall, a roller rink, and, by the 1950s, a destination for some of the biggest names in contemporary black music. In December 1965, Bill Graham staged his first events there, and for the last 40 years, it has been the undisputed pinnacle of popular music venues, interrupted only slightly by the Loma Prieta earthquake of 1989 and the tragic death of Bill Graham in 1991. Today it carries on in true San Francisco fashion, as the cutting edge of yesterday becomes the tradition of today.

Originally it was a roller skating rink called Dreamland, named after its predecessor on the same site. In the 1940s, it was Winterland and, for 25 years, housed Shipstad and Johnson's annual Ice Follies. But few seem to remember that now because of the building's latter-day fame (beginning in the mid-1960s) as Bill Graham's fabled home of rock music and the home of the Grateful Dead. Winterland was a dump, but what a dump! Creature comforts were never a consideration; one musician called it an "acoustical snakepit." The building was literally crumbling to pieces, but overflow crowds didn't care; this was their cathedral. By the late 1970s, the building had deteriorated beyond all affordable repair and, on December 31, 1978, was given its final rites, a rock concert to end all rock concerts, a farewell to end all farewells.

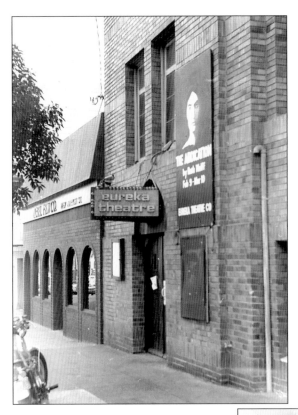

The Eureka Theatre Company was founded by Robert Woodruff and Chris Silva as the Shorter Players and began operations in 1972 at the old Trinity Methodist Church at 2299 Market Street. The building was destroyed by fire on October 11, 1981, and in 1984, the company moved on to a new location in a former warehouse at 2730 Sixteenth Street, between Harrison and Folsom Streets. Despite having attained a national reputation for staging socially and politically conscious works, a 1992 financial crisis threatened to put them out of business, but in true San Francisco tradition, they survived and can now be found at the former Gateway Cinema site at 215 Jackson Street as 42nd Street Moon.

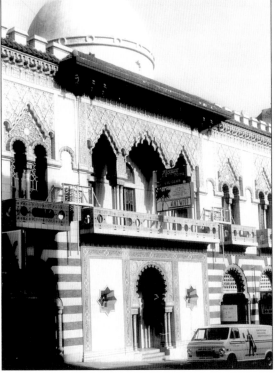

The Alcazar Theatre at 650 Geary Street is the fourth site to bear that name. Formerly a Masonic Temple with adjoining garage, the building has a Moorish exterior that befits the Alcazar name better than any of its predecessors, but the style is not carried over into the functional 499-seat interior. Opening in 1976, the Alcazar has a 30-year history that includes a series of hits and misses, with long closures in between.

Club Fugazi at 678 Green Street suggests three words: *Beach Blanket Babylon*. For over 30 years and 10,000 sold-out performances, Snow White has been searching for true love in what the *San Francisco Chronicle* aptly describes as "a non-stop onslaught of musical, celebrity and pop-culture lampoons and fantastically sculpted hats and hairdos." The show is an internationally acclaimed San Francisco institution that will most likely play forever.

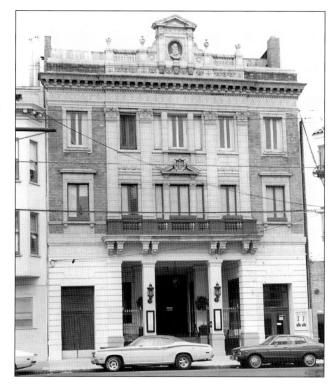

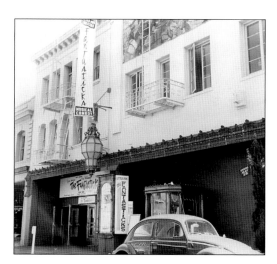

Pacific Avenue between Kearny and Montgomery Streets was once the Barbary Coast, one solid block of night spots of every imaginable kind. During the mid-1940s, it called itself "International Settlement," and there one could find the House of Blue Lights, Spider Kelly's, and Bee and Ray Goman's Gay '90s. And right in the heart of it all, at 533 Pacific Avenue, sat the aptly named Barbary Coast. The block settled down to a peaceful slumber in the postwar 1950s and early 1960s, then came alive again as the words "North Beach" took on a new meaning to a new generation. Carved out of the old Barbary Coast site, with genuine artifacts from the now destroyed Fox Theatre, the Little Fox opened its doors on August 27, 1963, and immediately became a popular venue for intimate long-run productions such as *The Fantastics* (shown here), *One Flew Over the Cuckoo's Nest*, which ran for five years, and *You're a Good Man, Charlie Brown*. It too has vanished now, the premises having been converted into an office building, and no hint of the Little Fox remains.

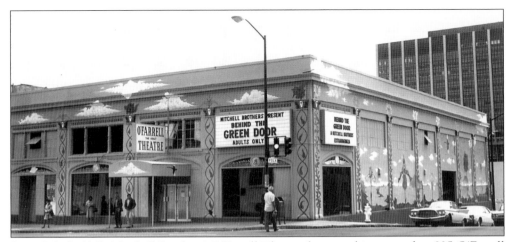

Since July 8, 1969, Mitchell Brothers' O'Farrell Theatre has stood its ground at 895 O'Farrell Street, at the southeast corner of Polk Street. Its colorful history, particularly that of its ill-starred entrepreneurs, Jim and Artie Mitchell, and Marilyn Chambers (the Ivory Snow Girl and star of *Behind the Green Door*), would fill a book. From a theatrical standpoint, the O'Farrell's muralled building and eye-popping marquee attest to its survival skills in a highly competitive world.

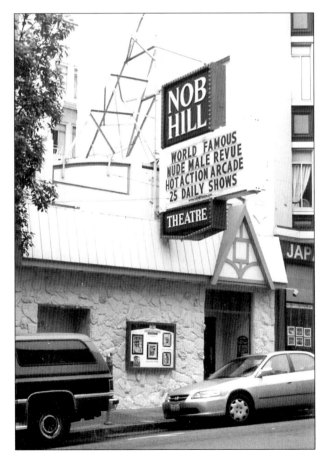

Dating back to the 1970s, the Nob Hill at 729 Bush Street is another 30-year veteran of the San Francisco scene. Originally strictly a film emporium, it eventually converted to projected video and then to live nude male entertainment.

Three

INTERNATIONAL ART AND REPERTORY

The "international" cinema scene really began in 1935 when the Avalon (formerly Regent), a small neighborhood house that had been around since 1914, reinvented itself as the Clay International with a new programming format that proved immediately popular and continues so today. After the end of World War II, foreign films became the favorite dish of film-going connoisseurs as new outlets sprung up everywhere and prospered for the next 20 years. The word "international" evolved into "art" and later "repertory" but they are still a variation of the same theme. Ethnic theatres (those catering to a specific non–English-speaking clientele, showing films in a foreign language, often without subtitles), began in Chinatown, then spread elsewhere, as Spanish films moved into the Sutter in 1941, then expanded to the Victoria, while Japanese films took over the Rio, and German cinema had its day at the Rita and Roxie. Meanwhile, the decade of the 1970s emerged as the decade of revival, led by the Gateway, the Richelieu, and, eventually, the Castro.

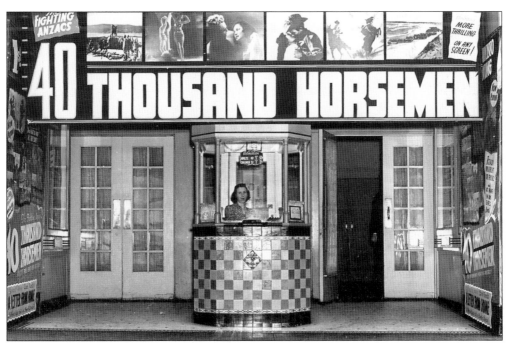

The Larkin is pictured here in January 1942 showing *40,000 Horsemen*, an Australian import deemed so important it was shown concurrently at both this theatre and the Clay.

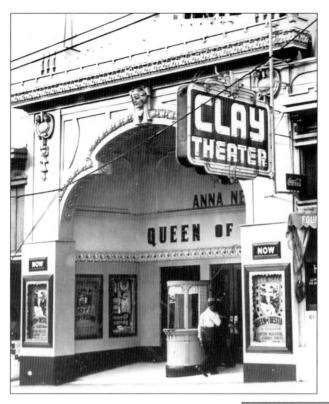

The Clay Theatre at 2261 Fillmore Street opened as the Regent in 1914, was renamed Avalon in 1931, and became Clay International on April 11, 1935. Operated today by Landmark Theatres, the Clay and its original facade, pictured here in 1938, are still quite recognizable as the theatre enters its tenth decade.

The Larkin Theatre at 816 Larkin Street opened in 1916 and joined the Clay in the 1940s as one of San Francisco's leading international sites. By the 1950s and 1960s, long runs such as *Never On Sunday* (34 weeks) and *Diabolique* (24 weeks) were not uncommon, prompting the opening of the nearby Music Hall. The most popular film of this period was *Room at the Top*, which shared screens at both Clay and Larkin simultaneously for 21 weeks in 1959. Those who chose the Larkin got an added treat of being able to stop in at the candy store next door and treat themselves to the best homemade Belgian chocolates ever imagined. The theatre was renamed the Century in 1979, live adult entertainment is its mainstay today, and the candy store is long gone.

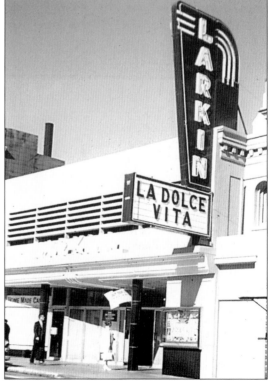

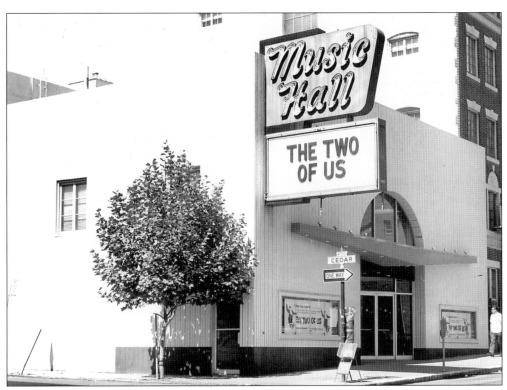

The Music Hall at 931 Larkin Street opened April 19, 1962, as a direct consequence of the logjam of specialized film product backing up on distributors' shelves resulting from the nearby Larkin's long runs. For a decade, the Music Hall rode the crest of the wave with such films as *Charly* (30 weeks), *Easy Rider* (29 weeks), and many more. Eventually, business began to wind down and it closed in the late 1970s. Today, it serves as a Chinese church.

The 198-seat Richelieu Cinema at 1075 Geary Street opened on March 13, 1963, and was developed from space previously used as Richelieu Casino. Like the first Nob Hill Theatre, it used rear-view projection, a system by which the picture is cast upon the back side of a transparent screen by a mirror placed at a 90-degree angle. After a dozen years of somewhat spotty bookings, the author took it over in 1975 as a companion house to the Gateway, offering a more arcane variety of revival programming (from early Tallulah Bankhead to *The Red Shoes*). Richelieu made the headlines in 1980 when it was badly vandalized, but not destroyed, by a group of Berkeley anarchists who objected to its sell-out showings of *Birth of a Nation*. After this setback, things got rolling again, but insurmountable architectural problems resulting from its location in the basement of the aging Richelieu Hotel brought about its final closure in June 1981.

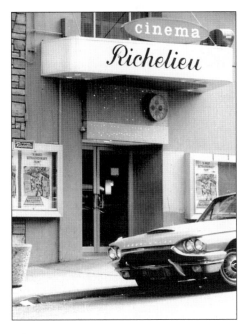

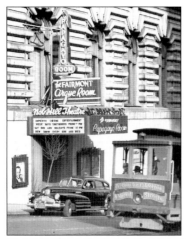

San Francisco's first Nob Hill Theatre at 950 California Street seated 250 and was carved out of a piece of the Fairmont Hotel. It opened on October 20, 1944, and closed 20 years later on October 27, 1964. Intimate and luxurious, it was a great place to see a movie, with the kind of seats you loved to sink down into; like the Richelieu, rear-view projection was its trademark. Catering mostly to Nob Hill locals, it didn't really benefit from tourists, who, understandably, preferred riding cable cars to seeing a movie and found parking almost an impossibility. Later, the site became Masons Restaurant.

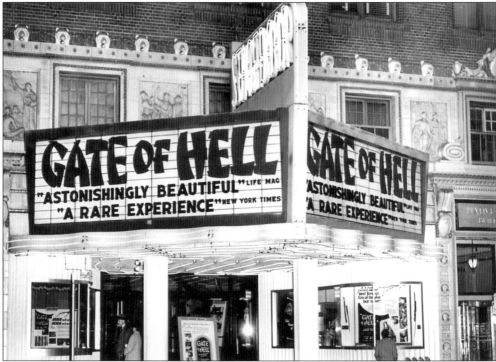

Built in 1911, the Stage Door Theatre began life as a concert hall for the Native Sons of the Golden West. During the World War II years, it served as San Francisco's Stage Door Canteen, a venue for armed forces personnel. After the war, it was converted into a film theatre and opened on September 30, 1946, with Laurence Olivier's *Henry V*, an immediate crowd pleaser that ran 33 consecutive weeks. During the next few years, with such offerings as *Hamlet* (1948–1949, 28 weeks), *Gigi* (1958–1959, 69 weeks), and *A Man for All Seasons* (1967–1968, 60 weeks), the Stage Door was one of the top international theatres in San Francisco, but it couldn't last as the changing mores of the 1970s took their toll. After a brief turn as "The San Francisco Experience," it operated through the decade of the 1980s as the Regency III and then closed in 1989. After the 1989 Loma Prieta earthquake devastated the nearby Geary, the American Conservatory Theatre took over the site for a while and renamed it Stage Door until they got the Geary back in shape. Today it is Ruby Skye, a popular upscale night club.

The Gateway Cinema at 215 Jackson Street opened November 15, 1967, as part of the Golden Gateway Center redevelopment project. For 10 years, from 1971 to 1981, it was operated by the author as San Francisco's first full-time revival cinema, offering 35-millimeter prints of films from the Golden Age of Hollywood. In this 1976 photograph, sell-out crowds line up to see a Gateway-subsidized, newly struck, three-strip Technicolor print of *The Adventures of Robin Hood*, starring Errol Flynn. Titles like *The Thin Man*, *Casablanca*, and *The Maltese Falcon* were crowd-pleasers that made numerous returns to the Gateway screen. Today the Gateway building houses Eureka Theatre's 42nd Street Moon.

Each April, on the anniversary of the 1906 San Francisco earthquake and fire, the Gateway featured the Clark Gable and Jeanette MacDonald classic *San Francisco* along with a festival of historically related short subjects seen nowhere else. The entire program became an annual Gateway trademark and many patrons returned year after year to see the show, cheer Jeanette singing the title song (just before the quake), and join in on "The Battle Hymn of the Republic" afterwards, as the stars marched out of the ruins promising to "build a new San Francisco!"

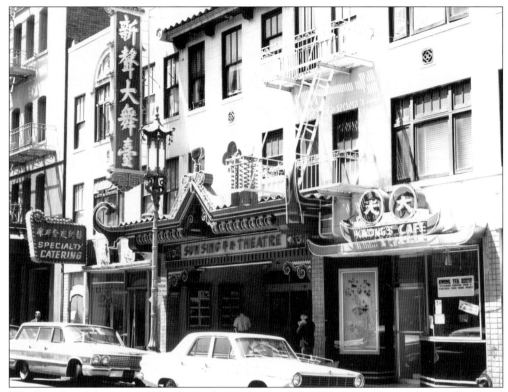

The Sun Sing Theatre at 1021 Grant Avenue opened in 1909 as the Oriental; in 1924, it was renamed the Mandarin and, in 1950, Sun Sing. It closed in 1987 and has since been converted to retail space. It is rumored to be the theatre that Rita Hayworth visits in Orson Welles' 1947 *The Lady from Shanghai*, but it is probable that only the exterior was used and that the interiors were shot in Hollywood.

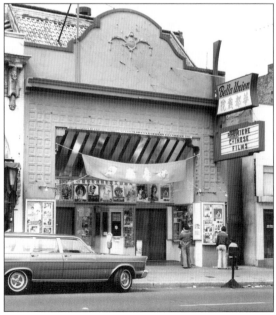

The Bella Union Theatre at 825 Kearny Street, opened in 1911 as the Shanghai but was soon renamed the Kearny. In the late 1940s, it offered Filipino Pictures as the Rex and attempted silent films a few times as the Bella Union. Eventually it changed over to Chinese films, still retaining the Bella Union name, finally wrapping it up in 1985. Today, it serves as retail space.

The Grand View Theatre at 756 Jackson Street was opened in the mid-1930s by Joseph Sunn as an outlet for his "Grand View Pictures," specializing in films imported from the Chinese mainland. In the late 1970s, it was renamed Chinatown Theatre and ran for another decade under that name. It closed in 1989 and is now a retail outlet.

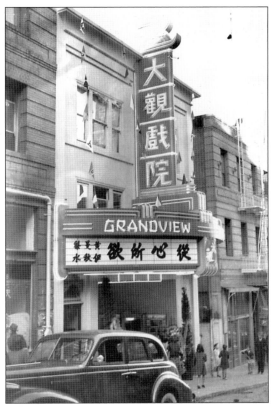

The Great China Theatre opened in 1925 at 636 Jackson Street and was renamed the Great Star in 1960. It has been closed for several years and now stands vacant.

The Rio Theatre opened as the Cory in 1913 at 2240 Union Street. After a variety of name changes, it settled upon Union in 1932 and then reopened as Rio on November 20, 1941, leaning eventually in the international direction. In the mid-1950s, it was known as Toho Rio, a popular and unique outlet of Japanese-made films. In 1968, it went mainstream again and was renamed Metro II; in its final years it was operated by John Buckley, of Cento Cedar fame, as the Mercury. It closed in 1986 and was torn down.

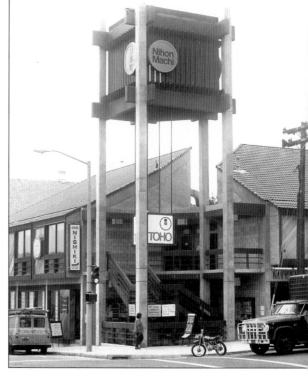

The Toho Theatre opened on July 31, 1971, at 1700 Post Street, adjacent to the newly developed Japantown Center. The following year, it was renamed the Kokusai and, for the next 15 years, showed Japanese films exclusively. It closed in 1987.

The Bridge Theatre opened July 21, 1939, at 3010 Geary Boulevard as a small sub-run Richmond district neighborhood house, named after the newly built Golden Gate Bridge. In the mid-1950s, it went international under the operation of Maury Schwartz and, like its sister the Clay, continues today under the management of Landmark Theatres. *Zorba the Greek* is its long-run champion, holding the screen for 29 weeks in 1965, followed by *Georgy Girl* with 23 weeks in 1966–1967.

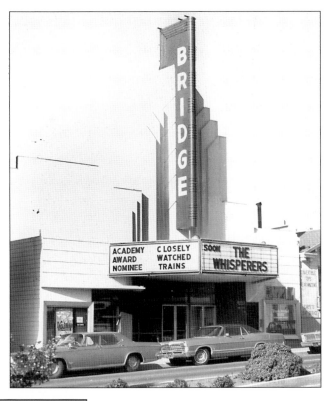

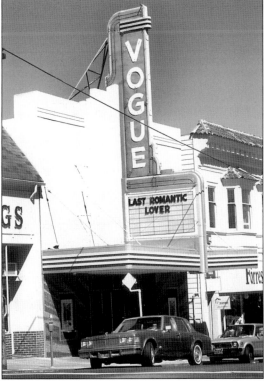

The Vogue Theatre arrived on the scene around 1912 as the Elite at 3290 Sacramento Street. After name changes (Rex in 1919, Plaza in 1927), it was upgraded and reopened as the Vogue on March 3, 1939. After a few years of running "single features exclusively" aimed toward the nearby Pacific Heights neighborhood, it went international and met with immediate success. *The Gods Must Be Crazy* ran for an incredible 70 weeks in 1984–1985, doubling the time of previous record-holders *The Last Picture Show* (35 weeks, 1971–1972) and *La Strada* (31 weeks, 1956–1957). Today it is operated by Regal Entertainment Group.

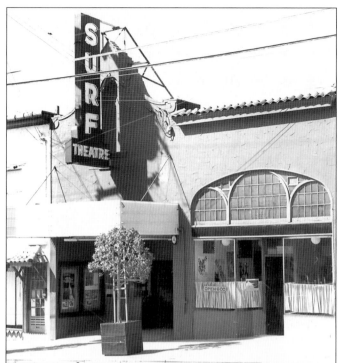

The Surf Theatre opened in 1926 as the Parkview at 4510 Irving Street and was renamed the Sunset in 1937. After serving the Outer Sunset district for 30 years, the site was remodeled and reopened as the Surf on July 24, 1957, by owner/operator Isabella Strohmeyer. At that time, she introduced a schedule of international programming. After a few years, it was taken over by Mel Novikoff, who made the Surf a popular destination for serious-minded moviegoers. Novikoff closed the theatre on July 7, 1985, and it has since become a Chinese church.

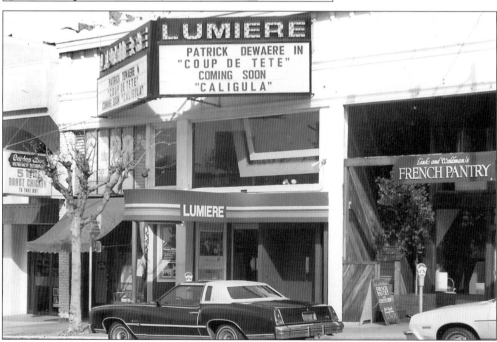

Another Novikoff house was the Lumiere at 1572 California Street, which he developed out of the old (live) Firehouse Theatre and opened on January 24, 1975. Taking over space next door previously occupied by the New Era Bookstore and later the French Pantry, Novikoff expanded the site to three screens and reopened it as Lumiere 3 on December 16, 1983. Today, it is operated by Landmark Theatres.

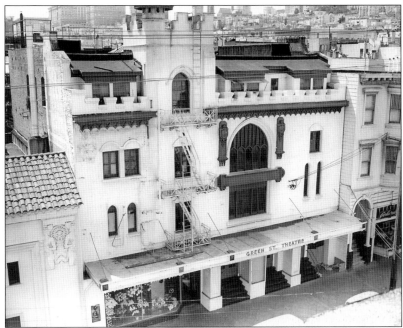

The Green Street Theatre, across the street from Club Fugazi, opened in July 1924 as Teatro Allesandro Eden at 631 Green Street. In 1927, it was rechristened the Green Street Theatre and, for the next 28 years, offered a potpourri of film and live entertainment, mostly catering to North Beach's Italian community. One of its noteworthy successes was a live presentation of the Victorian melodrama *The Drunkard*, done in tongue-in-cheek style. It became a popular long-running favorite during the mid-1940s. The Green Street closed in 1955 and was torn down.

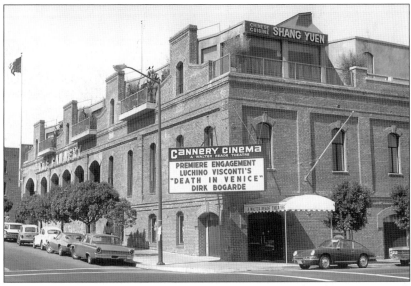

The 295-seat Cannery Cinema opened on September 16, 1971, in the old Cannery Building near Fisherman's Wharf. Badly laid out, it was never popular among moviegoers for a variety of reasons. About the only time anyone ever went to the Cannery was when the film was something they particularly wanted to see, and it was not being shown anywhere else. It closed as a film theatre in 1993 and is now a bar.

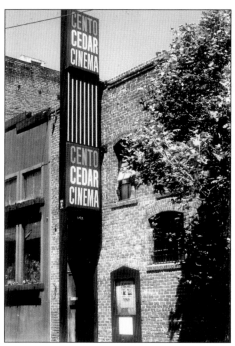

The Cedar Alley Cinema opened on August 14, 1965, at 40 Cedar Street as a small repertory house situated in a narrow alley between Polk and Larkin Streets, a half block north of Geary. It was renamed Cento Cedar Cinema on October 6, 1967, and was later taken over by John Buckley, who had previously operated Fethers Point Cinema (1967–1972), a storefront in the Castro at 4416 Eighteenth Street. The Cedar Alley location was pretty bad to start with and only got worse as years went by. Buckley moved on to the Rio in 1983, and the next operators were soon overcome by the utter impossibility of the location. It closed in July 1984.

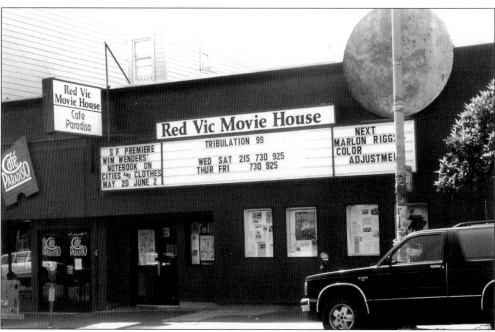

The first Red Victorian Movie House opened at 1659 Haight Street on July 25, 1980. Run by members of the Red Vic Movie House collective, it enjoyed 10 prosperous years of neighborhood support, but a sometimes hostile landlady-tenant relationship forced its closure on May 20, 1990. Undaunted, the Red Vic team moved a block up the street, took over the former Full Moon Saloon at 1727 Haight Street, and reopened on June 14, 1991, without dropping a stitch. Offering films as eclectic as the neighborhood they call home, the Red Vic is as firmly entrenched in the Haight Street counterculture of today as it was two and a half decades ago.

Four

THE MISSION

From Sixteenth Street to the San Mateo County line, a dozen and a half theatres—with a total seating capacity of around 15,000, ranging in size from 2,575 seats (El Capitan) to 250 seats (Cameo), and all of them second-run and sub-run houses—once catered to the tastes of San Francisco's sprawling Mission district. Every one of them are gone now except for two of the oldest, the Roxie and the Victoria on Sixteenth Street, two survivors by every definition of the word.

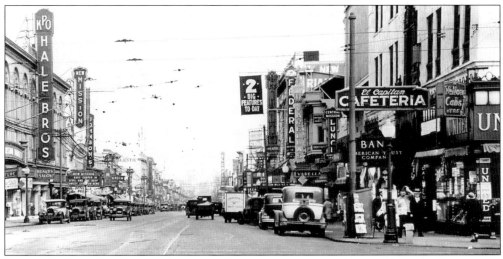

This 1932 view of Mission Street, looking north from Twenty-second Street, shows the New Mission on the left, with its comparatively small original vertical sign, and the Rialto (formerly Wigwam, later Crown and Cine Latino) on the right. Off in the distance, the familiar El Capitan vertical looms two blocks to the north, while El Capitan Cafeteria (far right) undoubtedly benefited from moviegoers at all of the above.

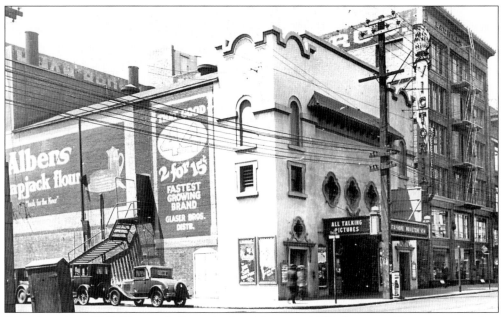

The Victoria at 2961 Sixteenth Street is the oldest post-1906 theatre still operating in San Francisco. It opened in late 1907 as the Sixteenth Street, was once known as Brown's Opera House, and was renamed Victoria in 1914 when it became a film house. In the 1940s, Victoria picked up the Spanish-language film policy of the former Teatro Sutter and, after the closing of the President Follies, reinvented itself as the New Follies and San Francisco's resident burlesque theatre on April 30, 1964. Thirteen years later, it once again became the Victoria, a name it still proudly claims today, with an interesting array of offbeat live shows and film programs.

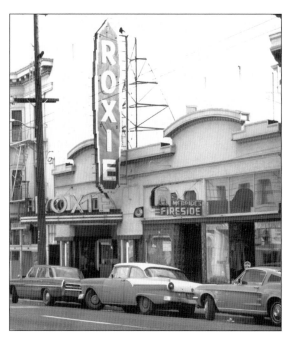

The Roxie Theatre at 3117 Sixteenth Street was opened in 1909 by C. H. Brown, who later moved down the street to today's Victoria, which he dubbed Brown's Opera House. This site underwent an array of name changes—Poppy, Rex, Gem, and Gaiety—before Roxie took hold in 1933. Seven decades later, it gave birth to the 49-seat Little Roxie in a storefront next door. Today, under the guidance of Bill Banning, a diverse schedule of independent programming keeps the wickets turning at both venues. During the intervening years, the Roxie had a little sister down the street—the Cameo at 3040 Sixteenth Street—that opened in 1913 as the Opal and closed in 1952. There is no trace of the Cameo today.

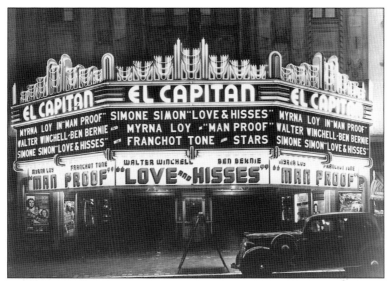

El Capitan opened on June 29, 1928, at 2353 Mission Street. Designed by G. Albert Lansburgh, it initially boasted a seating capacity of 3,100 (which would place it at the top of the list until the 4,650-seat Fox came along a year later), but its later-quoted figure of 2,575 seems closer to the truth. Built for Ackerman and Harris, it later became Fox West Coast's Mission Street Showcase and, in the 1950s, was the first neighborhood theatre to offer CinemaScope and Stereophonic Sound. Too much competition, an ever-increasing overhead, and television combined to bring about its early demise, and it closed on December 15, 1957. The theatre was torn down, but its facade, which is part of the adjoining El Capitan Hotel, remains as a reminder of better times. A parking lot has replaced the theatre building itself.

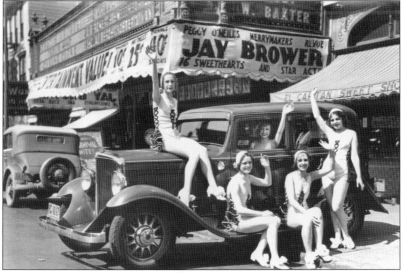

Offering a combined policy of stage and screen attractions, El Capitan became immediately popular but soon experienced the woes of the Depression. For 10¢ (matinees) or 25¢ (evenings), customers got the latest Warner Baxter feature film, *Amateur Daddy*, plus Jay Brower and Peggy O'Neill's *16 Sweethearts* and *Merrymakers Revue*. Apparently, a 1932 Essex Sedan is also somehow involved in all this, perhaps as a door prize. Four years later, the Peggy O'Neill Revue finally made it downtown and popped up at the Golden Gate.

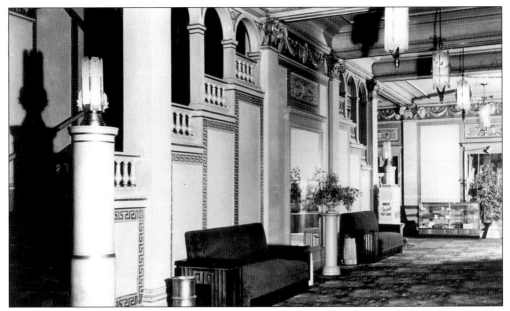

In the early 1930s, the New Mission was extensively remodeled by Timothy Pflueger, who masterfully blended the art deco trends of that decade with more traditional styles of 20 years earlier when the theatre was first opened. In this early 1940s photo, the stately but inviting lower lounge greets moviegoers with solidarity and taste, marred only by a hot popcorn machine and tiny snack bar.

The Pflueger touch graces the New Mission's outer lobby in a style that sports just the right combination of gold leaf and good taste.

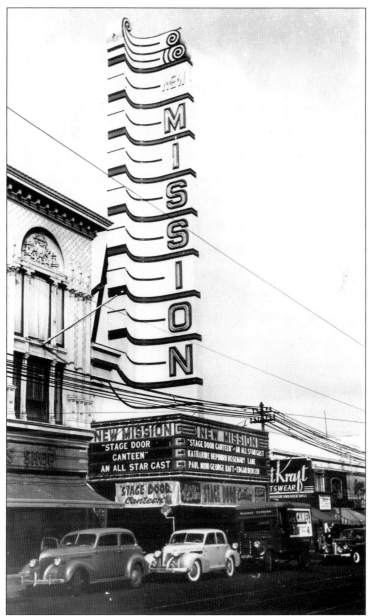

The New Mission Theatre opened on May 14, 1916, at 2550 Mission Street. Soon it closed, added a second balcony, and reopened on November 15, 1917, with 2,020 seats. Designed by Reid Brothers, the original lobby was developed out of the space previously used by the much smaller Idle Hour theatre, and the auditorium was added afterwards, forming an L-shaped structure. In the early 1930s, Nasser Brothers, who owned and operated it as one of their two flagship houses (the other being the New Fillmore), commissioned architect Timothy Pflueger to bring it up to date. What remains in the memories of those who attended it in its heyday, as well as those who are fighting for its preservation today, is the result of this remodeling, most noticeably its enormous art deco vertical, a Mission Street landmark for over 70 years. Diminishing attendance, the inevitable result of an increasingly unsafe neighborhood environment, brought about its closure on May 4, 1993.

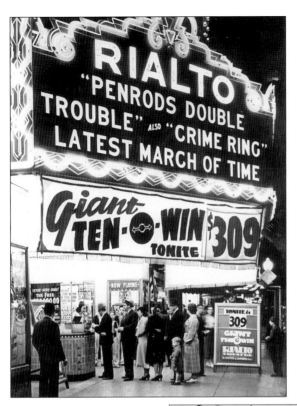

Mission Street's first post-1906 venue, the Wigwam Theatre, was a short-lived affair at 2547 Mission Street. It opened in 1907 and closed in 1913, at which time it was torn down and replaced by the larger, more permanent structure that still stands today at 2555 Mission Street. This second Wigwam opened on July 24, 1913, with a combination of vaudeville and motion pictures. On February 1, 1930, it was renamed and reopened as the New Rialto. Operating in the shadows of the mighty New Mission across the street and the El Capitan two blocks away, the New Rialto offered lower prices, lesser films, and a chance to win the jackpot at Ten-O-Win.

After World War II, the Rialto was renamed the Crown and, on October 17, 1947, reopened with a monstrous vertical sign announcing its newest identity. The Ten-O-Win game had vanished, but the programming had not improved very much. On July 3, 1974, another name change to Cine Latino signaled its changeover to Spanish-language films, keeping the doors open for another 13 years. At that time, falling revenue—the result of unsafe streets as much as anything else—caused it to close permanently. Today it stands vacant.

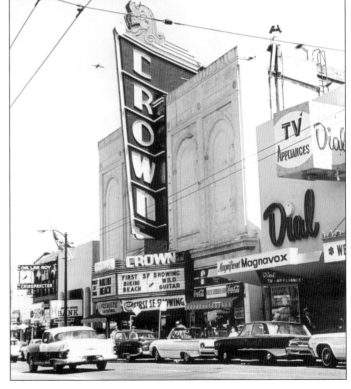

The Tower Theatre opened as the Majestic in 1912 at 2457 Mission Street and was later upgraded in the popular 1930s moderne style. It was renamed the Tower on February 20, 1942, and by the 1960s, it had become the home of Spanish-language films and was the last film theatre to operate on Mission Street. It finally closed in 1998 and is a Mexican church today.

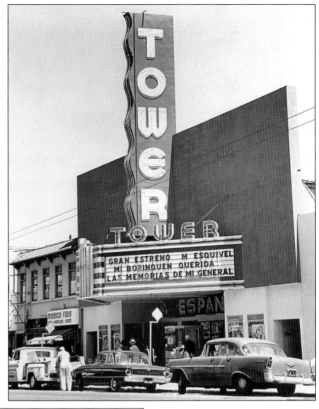

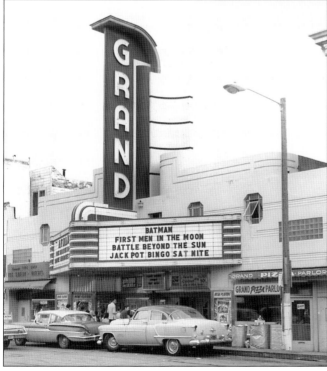

The moderne-style Grand Theatre at 2665 Mission Street opened on March 23, 1940, making it the youngest and southernmost theatre of the latter-day Inner Mission community. It was also the last San Francisco theatre to open before the outbreak of World War II. Offering late runs at bargain prices, it appealed to budget-conscious families. Here, in the late 1960s, the Grand offers three pop hits plus Jackpot Bingo. The Grand closed in 1988 and is now an Asian bazaar.

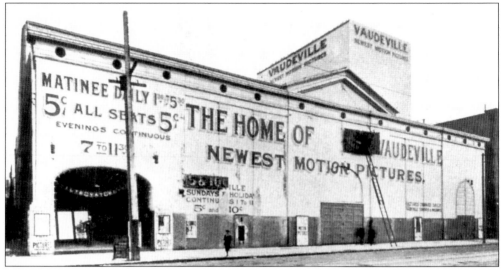

The Globe Theatre at 2731 Mission Street (between Twenty-third and Twenty-fourth Streets) lasted from 1907 to 1915 and typifies what disappeared when more substantial theatres like Majestic/Tower, Wigwam/Rialto, and New Mission began to appear in the early and mid-1910s. For a nickel in the afternoon or a dime in the evening, audiences certainly got their money's worth of vaudeville and the "newest motion pictures," but audiences soon came to expect something better.

The original, Spanish-style Mission Theatre at 2605 Mission Street (at Twenty-second Street) opened in 1905. Luckily, it was located outside the immediate zone of impact of the April 1906 earthquake and escaped the devastation that destroyed most of San Francisco's other houses. Just two months later, it cheerfully reopened on June 16, 1906. The following year it was renamed the Grand, then in 1919 the Real-Art. It closed in 1925 and was torn down.

The Cortland Theatre opened in 1915 at 802 Cortland Avenue and, for the next 50 years, provided low-priced family entertainment to the self-contained neighborhood on the southern side of Bernal Heights. It was given a new false front and renamed the Capri on June 16, 1957, and closed April 13, 1969. Today it continues to serve the neighborhood as a church.

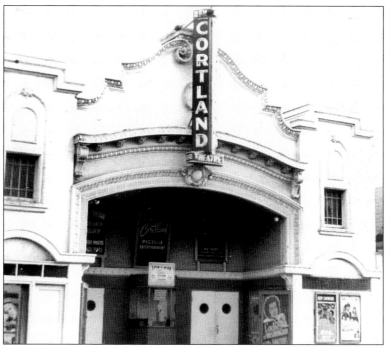

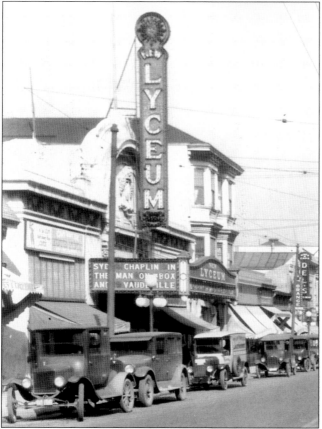

The Lyceum Theatre at 3350 Mission Street was one of the first substantial, larger theatres built in the Mission district; it sported 1,400 seats when it opened in 1907. It closed in 1964, was used a church for a while, and then was torn down to make way for a grocery store.

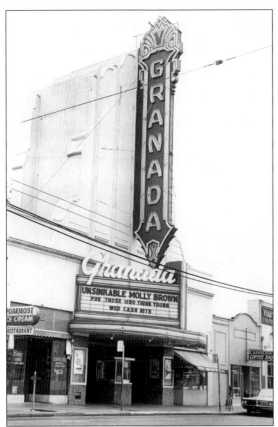

The Granada Theatre at 4631 Mission Street, opposite Ocean Avenue, opened in the early 1920s as the Excelsior. A few years later it was extensively upgraded and reopened as the Granada on October 3, 1931. Its ornate art deco vertical sign was transferred from the previous downtown Granada, now renamed Paramount, and retained its identifying trademark until it closed in November 1982. Today it houses a Walgreens and Goodwill store.

The Amazon Theatre opened on September 14, 1928, at 965 Geneva Avenue, serving the nearby Crocker-Amazon district. It soon became an anchor to the Geneva Avenue shopping area. On October 23, 1969, it reopened as the Apollo and soon began showing Filipino films. It closed in 1980 and is presently being converted into housing units.

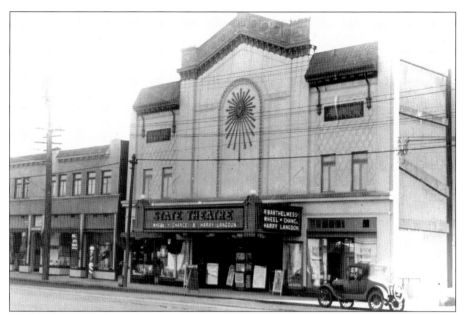

The State Theatre at 5825 Mission Street (not to be confused with the downtown State, formerly the California) is a genuine curiosity. It opened around 1925 and closed in 1931. Then, for reasons known only to Golden State Theatres, it reopened in 1947 as the Del Mar, offering odds and ends of filmdom, last runs and re-runs apparently found unworthy of being shown at its neighbor theatres the Amazon and Daly City. With a haphazard policy such as this, it was no surprise when it closed its doors for the last time on October 23, 1950. For the last 50 years, it has been the home of the San Francisco Christian Center.

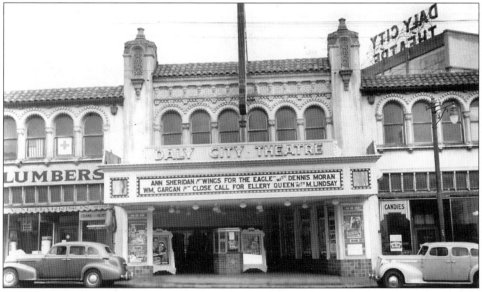

The Daly City Theatre opened just south of the San Mateo County line on November 27, 1928, at 6212 Mission Street. It held its ground until 1952, by which time it had lost a large percentage of its patronage to the nearby Mission and Geneva Drive-Ins. It was torn down in 1958 to make way for a supermarket. The pleasant atmospheric design of its auditorium was the only one of its kind in or near San Francisco.

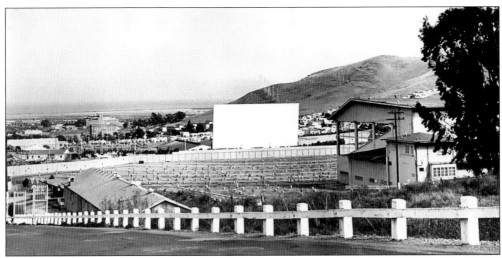

Technically, only one drive-in theatre ever operated within the San Francisco city limits, the short-lived (and, apparently, unphotographed) Terrace Drive-In at 451 Alemany Boulevard. It was located east of the Mission Street viaduct in an area now traversed by Interstate 280. It opened May 29, 1951, and closed January 31, 1954, officially the victim of too many foggy nights. Meanwhile, the Geneva Drive-In at 2150 Geneva Avenue in Daly City (which opened June 15, 1950, added two more screens in the 1970s, and closed September 1998) had a much longer and more successful career as San Francisco's number one drive-in, even though customers had to cross over into San Mateo County to reach it.

The Mission Drive-In Theatre's official address was 5500 Mission Street, but that was only its mailing address, in order to give it a San Francisco identity. Like the Geneva, the site itself was located across the county line, atop Guttenberg Street in Daly City. It opened on May 2, 1951, and closed October 5, 1976. During this time, it developed a well-earned reputation for harboring a pretty nasty clientele; it was not the sort of place to bring the wife and kiddies for a night out at the movies.

Five

THE NEIGHBORHOODS

Every neighborhood in San Francisco had at least one theatre. In an era when going downtown to a movie was time-consuming and more expensive, a large percentage of the population was quite content to catch films within walking distance of where they lived, even if they had to wait a few weeks for them to get there. The theatre was often the anchor of a neighborhood and was surrounded by all the shops necessary for day-to-day living, as well as the inevitable schools and churches. Kids attended school together, lived within a few blocks of one another, and all went to the movies on Saturday afternoon. Their parents saw neighbors at church on Sunday morning and at the movies on Sunday afternoon. The neighborhood was truly an extended family.

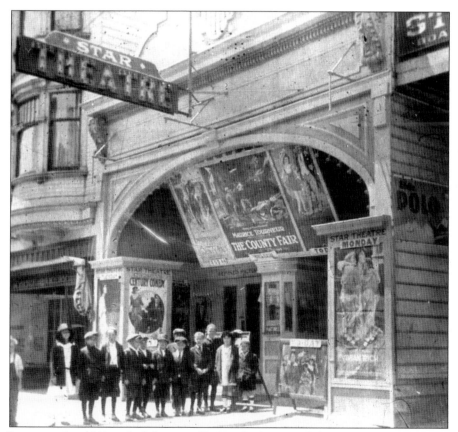

The Star opened in 1910 as the Liberty at 554 Haight Street and closed in 1926. It was torn down and replaced by the Riviera/Midtown on the same site, today a housing block known as the Theatre Lofts. This rare 1921 photograph evokes what words cannot about a long-gone era.

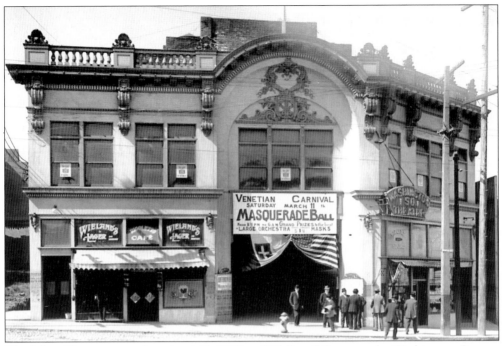

The Palace Theatre opened on April 10, 1909, at 1741 Powell Street as the Washington Square, a leading entertainment center in the North Beach community. In this 1911 photograph, it plays host to the Venetian Carnival and Masquerade Ball. In the late 1920s, the Palace converted to sound motion picture presentation and operated from 1929 to 1937 as the Milano. It then received a moderne remodel and emerged on November 5, 1937, as the Palace.

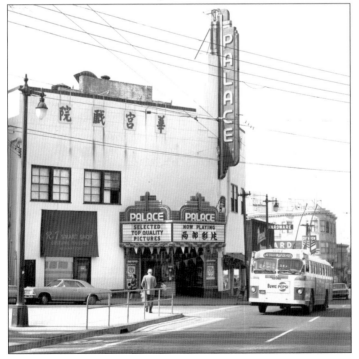

From 1937 through the 1960s, the Palace offered mainstream and second- and third-run Hollywood movies but, by the 1970s, had gone over to Chinese films. It was renamed Pagoda Palace on August 5, 1974, and continued to operate under that identity until it closed in November 1994. Its future remains uncertain.

The Verdi Theatre opened in 1909 at 644 Broadway as the Royal Palace. It was christened the Verdi in 1914 and, for the next 40 years, offered both third-run Hollywood films, Bingo, and occasional Italian films for the benefit of its North Beach patronage. In 1954, it was renamed the World, when its neighbor from across the street, the former Liberty (which had been operating as the World for the previous five years), closed and was torn down.

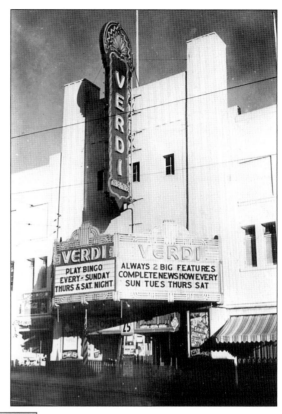

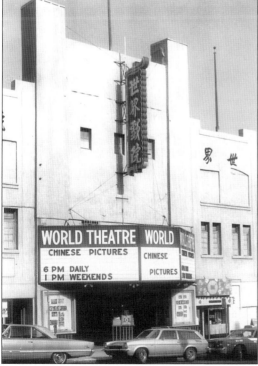

As the World, the Verdi initially offered foreign films, mostly of European origin. However, it soon became a 100 percent Chinese-speaking venue and remained as such until it closed and was torn down in 1983. A smaller World Theatre was built on the site as part of a multipurposed retail structure. It opened on July 1, 1985, and operated there for the next 15 years.

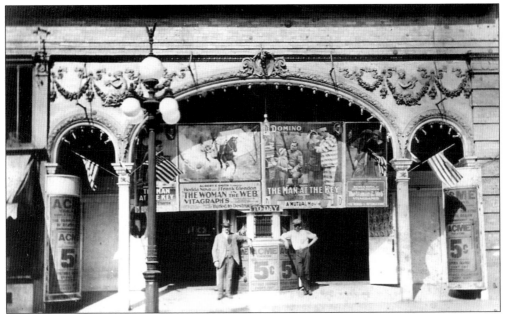

It is 1915, and the proud entrepreneurs of the five-cent Acme Theatre at 1249 Stockton Street achieve immortality along with their handsome establishment in this photograph.

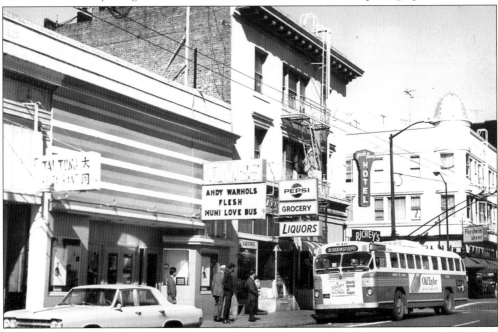

The Acme, which had opened in 1910, received a much needed rehab and reopened on March 10, 1949, as the Times, offering last-runs at low prices for its North Beach regulars. By the early 1970s, the local crowd had faded away, and Mike Thomas took it over as an offbeat cinema, catering to more bizarre tastes. If you saw Andy Warhol's *Flesh*, you probably saw it here. You may even have taken this 30 Stockton to get here, but it probably wasn't quite the same as the *Muni Love Bus* advertised on the marquee. The Times closed on December 26, 1976, and now houses a Chinese retailer.

Ghirardelli Square Cinema was carved out of Ghirardelli Square on the southeast corner of Beach and Polk Streets (formerly occupied by the Hungry I #2 nightclub) and opened on August 20, 1971. Although it played host to its share of popular first-run films, it was not the best place to see them, with a relatively small screen scrunched into the corner of the space and strange sight lines. It closed in December 1986 and was reopened briefly the following year as the Waterfront Theatre, offering live entertainment before closing permanently.

The Northpoint Theatre opened on June 28, 1967, on the southeast corner of Bay and Powell Streets. Its exterior was functional brick modern, but its interior offered the best of all worlds: a wide screen, stereophonic sound, and ultra-comfortable seats. Film distributors and the public alike always welcomed a run at the Northpoint because they knew the film was being presented under the best possible conditions. Such 1970s and 1980s fare as *Cabaret*, *The Exorcist*, *Earthquake* (in "Sensurround"), *Three Days of the Condor*, *All the President's Men*, *Superman*, and *Alien* were among the films that delighted audiences there. Dwindling attendance and a paucity of films worthy of Northpoint presentation resulted in its closure on July 20, 1997. After sitting vacant for several years, it has recently been converted to retail space. In this 1979 photograph, the *Apocalypse Now* marquee poster hides the name of the theatre.

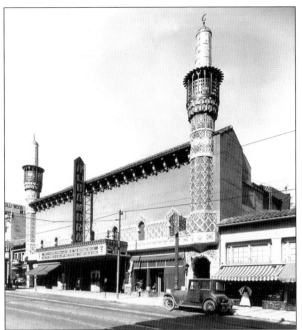

The Alhambra Theatre opened on November 5, 1926, at 2326 Polk Street. It was designed by Miller and Pflueger, and its Moorish minarets immediately became a local landmark. A 1976 twinning, in which in which the theatre was sliced down the middle into two ill-conceived halves, was undone in 1988 when it was beautifully restored to its former single-screen grandeur. The Alhambra survived another 10 years, but lack of available parking was always a problem and just one more reason why ticket sales decreased. It closed on February 22, 1998, and has since been converted into a Gorilla Gym, with much of its original decor and screen still intact.

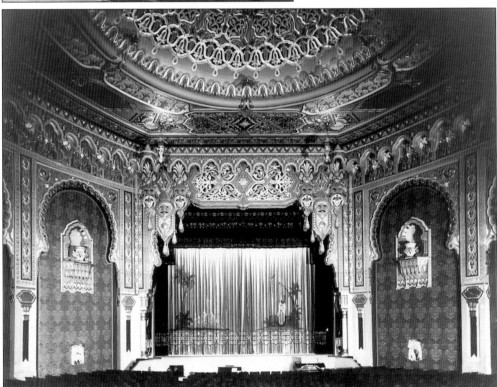

Here is the incredibly ornate interior of the Alhambra as it looked in 1926. In the 1950s, in order to accommodate proper CinemaScope presentation, a handsome wide curved screen was erected in front of the original, narrow proscenium, but after its 1988 restoration, a compromise had to be made with a much smaller screen so as not to obscure any of its original decor.

The Royal Theatre opened on September 6, 1916, at 1529 Polk Street and, for the next 80 years, was the identifiable anchor of the Polk and California intersection. Like so many others, it received a complete renovation and art deco facade in the mid-1930s, and this is the way it is remembered today, limited in its extravagance by its narrow 25-foot Polk Street frontage. It closed February 22, 1998, and was eventually torn down.

The subdued moderne interior of the Royal as it looked from the mid-1930s to the mid-1960s is shown here. Like the Alhambra, its narrow stage could not adequately offer worthwhile widescreen presentation, so a more satisfactorily proportioned screen was installed in front of the original proscenium, and the auditorium was draped to mask what was left of the decor.

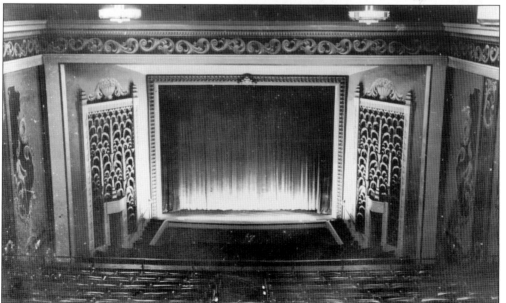

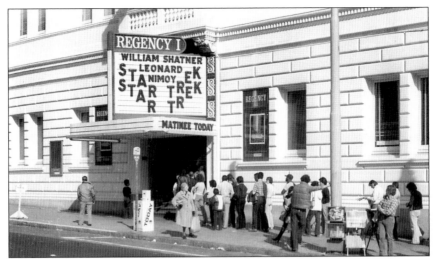

The Regency I at 1320 Van Ness Avenue was developed from the space formerly occupied by the Scottish Rite Auditorium (built in 1911) and opened on December 22, 1967. Managing to get more than its share of key bookings, it enjoyed a somewhat undeserved popularity among filmgoers. The Trekkies here would have been better off beamed up to some other venue, but the Regency saw to it that such an option was not possible. Handicapped-unfriendly outside stairs, a flat floor inside (yielding poor sight lines), a distracting side entrance to the auditorium, and a too-small-screen were their reward for patience, perseverance, and hard-earned movie money. Regency I closed on November 7, 1998.

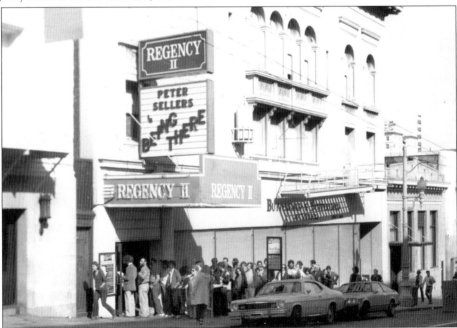

The Regency II at 1268 Sutter Street opened around the corner from the Regency I on December 25, 1969. It was developed from the old Avalon Ballroom site and was much more user-friendly. An escalator surmounted the stair-climbing problem, the wider auditorium yielded better sight lines, and a large curved screen offered a better picture. Perhaps this is why it outlived its neighbor, at least for another year and a half. It closed on March 26, 2000.

Today's Metro at 2055 Union Street opened on April 23, 1924 as the Metropolitan, another link in Samuel H. Levin's growing chain of neighborhood second-run theatres ("always nearest your home") that began with the Coliseum and Alexandria. After extensive remodeling, the name was wisely shortened to Metro, and it reopened on June 6, 1941.

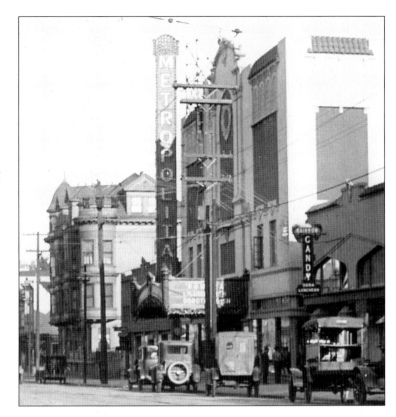

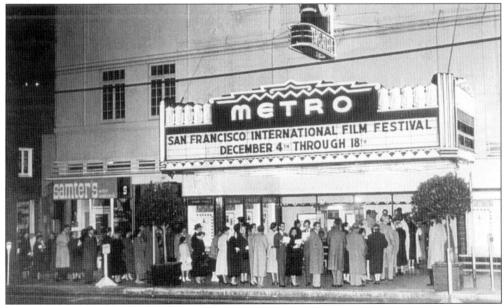

In the late 1950s, the Metro played host to the first San Francisco International Film Festival, thus increasing its prestige as one of San Francisco's leading first-run venues. Well-maintained and constantly upgraded, the Metro is the city's only surviving large single-screen theatre still in operation, apart from the Castro. Today, it is a part of the Regal Entertainment Group.

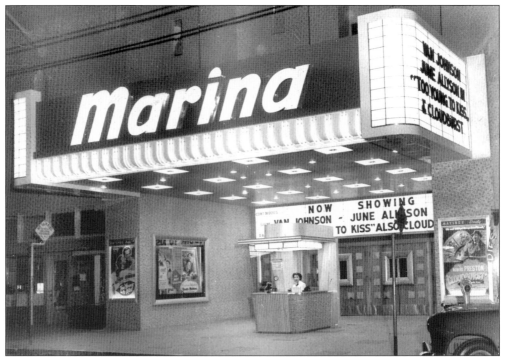

The Marina Theatre opened on September 6, 1928, at 2141 Chestnut Street and was designed by O'Brien Brothers & Peugh. In the early 1950s, it was extensively remodeled and updated, resulting in this streamlined box office and facade. Formerly operated by Gerald Hardy as a second-run house catering to the needs of the Marina district, it was taken over by Syufy Enterprises, which ended its days as a neighborhood theatre and reopened it as the first-run Cinema 21 on December 23, 1965. It was shuttered on September 20, 2001, and its future remains uncertain.

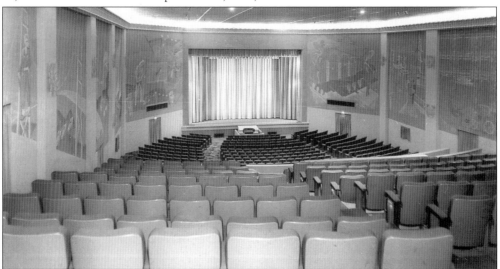

The interior of the Marina after its 1952 remodeling is shown here. Seating was reduced from 1,050 to 850 in order to accommodate wider, more comfortable loge-type seats, and San Francisco–themed murals were a unique identifying trademark of its acoustically treated walls. Unfortunately, they were later hidden behind the ubiquitous drapes of the 1960s.

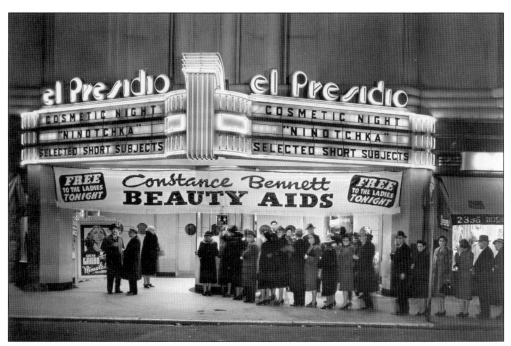

The El Presidio opened on July 1, 1937, at 2340 Chestnut Street. It was designed by John H. Ahnden in late-1930s moderne style and was built for less than $100,000. Its purpose was quite simple: to provide Marina district moviegoers with a third-run outlet for films they may have missed in their second-run engagements at the nearby Marina or Metro, a niche it adequately filled for the next 30 years. Here, on "cosmetic night," film star Constance Bennett's own personal line of "Beauty Aids" provides an added incentive for female moviegoers to line up to see Greta Garbo in *Ninotchka*.

El Presidio's unique style of moderne no-caps lettering vanished when its identity was simplified and it reopened on December 11, 1951, as the "Presidio." Catering to a new generation of filmgoers, the Presidio went "adult" in the late 1960s with such titillating fare as *Morianna* and *Skin on the Beach*, and, in 1972, with *Deep Throat*, for which ticket-buyers lined up around the block week after week. After having been closed for several months, the Presidio was reopened as a four-plex on December 25, 2004.

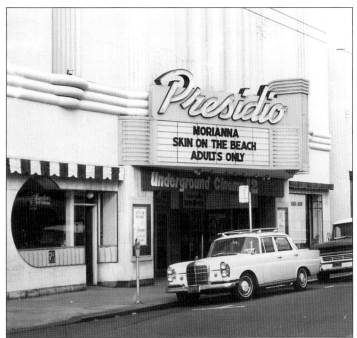

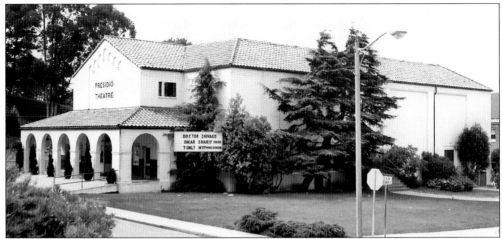

San Francisco's most unknown and hard-to-find theatre is the charming, Spanish-style Presidio Theatre at 99 Moraga Street in the Presidio of San Francisco. Built in the late 1930s by the WPA, the Presidio was designed to provide film entertainment to service personnel stationed or passing through the Presidio of San Francisco, and for 50 years, it did just that. With the closing of the Presidio Army Base, the theatre closed too. An attempt to reestablish it with a live retro-1940s revue failed to awaken the public's awareness of its existence, mainly because they simply couldn't find the place. Its future remains uncertain but will undoubtedly be linked to the future of the Presidio of San Francisco itself.

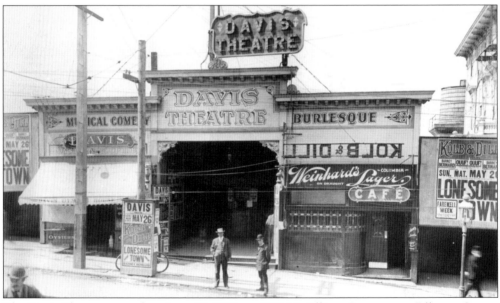

The Davis Theatre opened on June 30, 1906, at 1238 McAllister Street, near Fillmore Street, only two months after the earthquake. It was a welcome, if humble, venue to entertainment-deprived San Franciscans. It closed within a couple of years, as bigger and better sites were erected in the nearby Fillmore district, but for a time, it paid more than its share of dues by helping the shattered citizenry forget their woes. This May 1907 view is not reversed; the "Kolb and Dill" sign (advertising a popular comedy team of the day) is pushed flat against the building, so it appears backward. When it is swung out into the street after the theatre opens, it would read correctly, provided it was seen from the easterly direction.

After the earthquake and fire of 1906 wiped out all venues in the downtown area, theatre-hungry San Franciscans started building in the Fillmore district, which became a sort of temporary "downtown" for a few years. The Orpheum (left) at 1631 Ellis Street opened on January 21, 1907, and its next-door neighbor, the Princess (right), opened seven months later on August 31. When the new Orpheum opened downtown on O'Farrell Street, this one was renamed the Garrick and operated until 1924, after which time it became the Bagdad Bowl, then a church. The Princess was renamed the Ellis and reopened as a movie house on October 14, 1935; it closed on July 16, 1952, and also became a church. The two of them lasted until they were leveled by redevelopment in 1975.

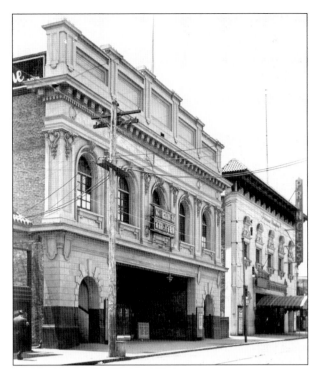

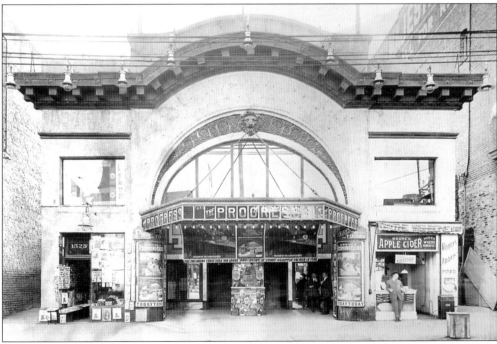

The Progress Theatre opened in 1911 at 1525 Fillmore Street and closed in 1925. A forgotten relic of Fillmore Street's past, the building survived redevelopment and still stands today on the west side of Fillmore between Geary Boulevard and O'Farrell Street. It was long ago converted to retail trade, leaving its theatrical roots unrecognizable.

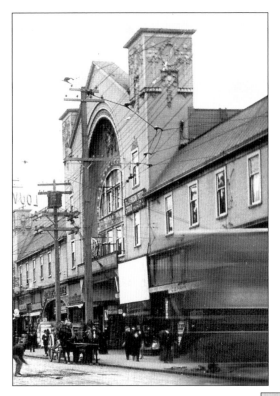

San Francisco's third (and final) Chutes Amusement Park, encompassing an entire square block from Fillmore to Webster, Turk to Eddy, opened on November 23, 1907, as Coney Island Park. It was renamed Chutes on July 14, 1909. Included on the grounds were several small nickelodeons, and on December 31, 1909, a 1,600-seat theatre was added. The entire park burned to the ground on May 29, 1911, but the brick-built theatre survived and literally rose from the ashes as the American.

The American Theatre opened in 1915 at 1226 Fillmore Street as the Lyric, making new use of the burned-out but still standing structure built for the Chutes Amusement Park. In 1925, it was renamed the American and lasted until 1959 as a low-priced, family-oriented neighborhood film house and was thereafter occasionally used for live shows. It was eventually torn down in the name of redevelopment.

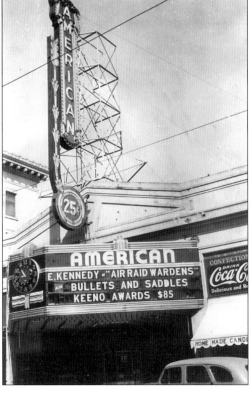

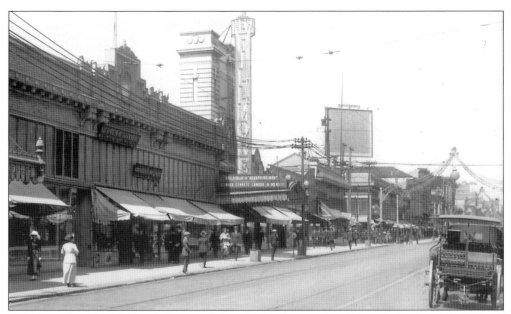

The New Fillmore Theatre opened on October 4, 1917, at 1329 Fillmore Street using the lobby of its predecessor (also named New Fillmore) as an access way to the much larger L-shaped 2,020-seat auditorium. This arrangement was a duplication of its sister theatre, the New Mission. In the 1930s, the New Fillmore also received an art deco upgrading by architect Timothy Pflueger, as did the New Mission. For the next 20 years, the two theatres operated as Nasser Brothers' "Twin Theatres," offering identical second-run programming for the neighborhood trade. Sadly, the deterioration of the surrounding area took its toll on the box office, and the New Fillmore closed in 1957. After standing vacant for many years, redevelopment leveled the site in the 1970s.

The Harding Theatre opened on May 8, 1926, at 616 Divisadero Street. Designed by the Reid Brothers, it was another link in Samuel H. Levin's chain of second-run neighborhood theatres. Its life as a film theatre ended in the 1960s, after which time it was taken over by the Lamplighters as the home of their Gilbert and Sullivan operettas. When the Lamplighters moved on to Presentation Theatre at 2350 Turk Street, the Harding served as a church for many years but now stands vacant and will most likely be torn down.

The Victory Theatre at 2030 Sutter Street opened on November 25, 1907. It was one of a cluster of post-earthquake Fillmore district venues. Two years later it was named Fischer's but is probably best remembered as Teatro Sutter, San Francisco's home of Spanish-language films from 1941 to 1954. Up the street, just barely visible in this 1909 photograph, Alexander Pantages operated the modestly sized Empire, which opened September 24, 1906, and was also known as the Pantages. It closed when he moved downtown to more impressive digs on Market Street in 1911.

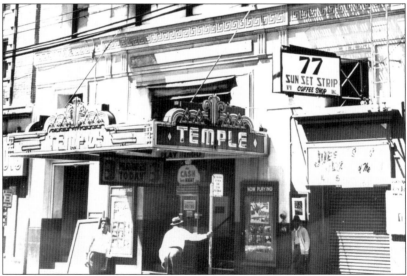

Fillmore Street's smallest theatre was the little Temple at 1745 Fillmore, which opened in 1918 as the Class A on the street level of the multi-storied Members of Light Grand Lodge Building. It was renamed the Temple in 1924; this program from that year lists admission prices ranging from 5¢ to 15¢. By the 1940s, admission was up to 25¢. The Temple closed May 30, 1966 and was torn down.

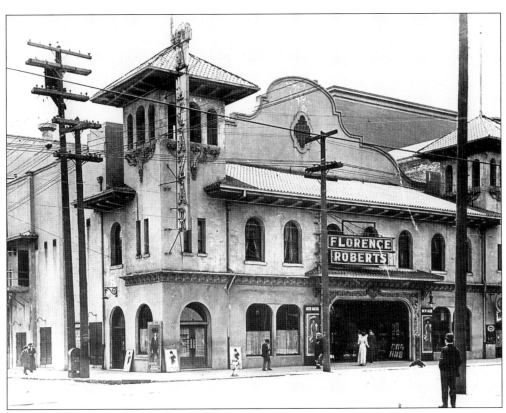

The Uptown opened on March 18, 1907, as the first post-earthquake Alcazar at 2101 Sutter Street. When the new downtown Alcazar opened in 1911, this one was renamed Republic. Originally built in the Mission Revival style, it underwent extensive remodeling and renovation in 1930 and reopened as the art deco Uptown, an upscale second-run film house catering to the tastes of nearby Pacific Heights.

This July 1949 photograph shows the Uptown in its prime, but it is the end of another era as streetcar service on Sutter Street is being phased out in favor of diesel busses. Eventually, the inroads of television and the decay of the neighborhood took their toll. By the late 1960s, the Uptown had lowered its sights considerably, running "underground films for mature swinging adults" as Lloyd Downton's Uptown. The end was near—it closed in 1970 and was torn down.

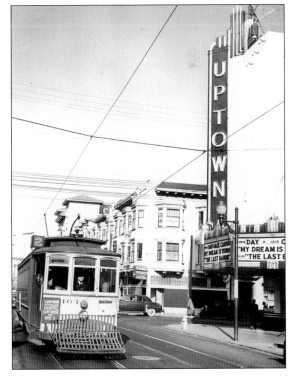

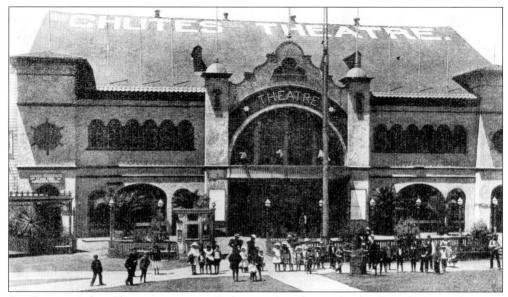

San Francisco's first Chutes Amusement Park opened on the south side of Haight Street, between Clayton and Cole Streets, on November 2, 1895, and closed on March 16, 1902. At the beginning it offered only a flat-bottomed boat ride that came plummeting "down the flume" into a pond beneath, but its popularity was so great that soon the Pavilion Vaudeville Theatre was added and, later, a scenic railroad, a zoo, and an "animatoscope" motion pictures. By 1902, it had outgrown its boundaries and moved west to Fulton Street and Tenth Avenue.

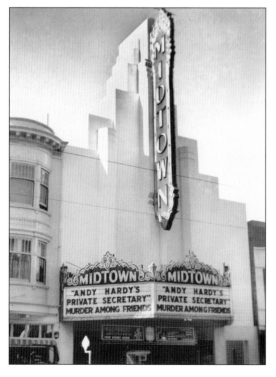

The Midtown Theatre at 560 Haight Street opened on March 5, 1927, as the Riviera on the site of the former Liberty/Star and was renamed the Midtown on April 29, 1935. After 25 years of service as a low-price, late-run neighborhood site, the premises were gutted by a fire on January 24, 1952, and the Midtown never reopened. For the next 50 years, it was a church but is now a trendy housing development called the Theatre Lofts.

The Haight Theatre at 1700 Haight Street first appeared around 1910. The sole surviving early photograph (from 1919) shows no similarity to the well-remembered structure at the corner of Haight and Cole Streets for the better part of the next 60 years. It was the cornerstone of the neighborhood for two generations, and this 1941 photograph shows it in its prime, with its moderne facade, the result of a 1930s redo. After closing as a film theatre in 1964, the site became an all-purpose venue to the Haight-Ashbury counter-culture of the mid-1960s and was renamed the Straight.

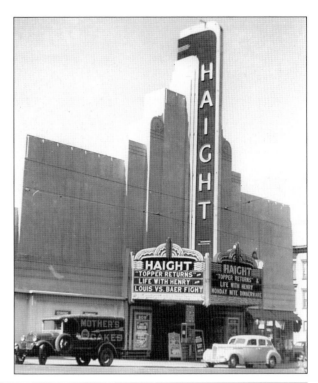

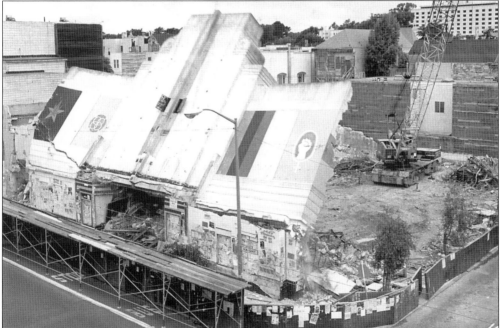

Repeated attempts to save the deteriorating structure for some kind of practical use failed, and the inevitable took place—the last moment of the Haight is captured here in 1979. This was shot by a well-known local photographer and historian (who has requested anonymity) who spent the better part of a foggy afternoon perched on a fire escape across the street in order to record the moment for posterity.

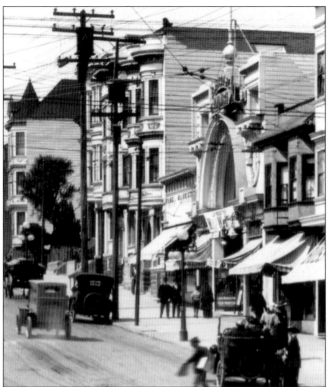

The Nasser Brothers' third theatrical venture, the Castro Street Theatre opened on December 21, 1910, at 485 Castro and closed on June 21, 1922, the night before the new Castro opened. It is now easily identifiable as Cliff's Variety Store.

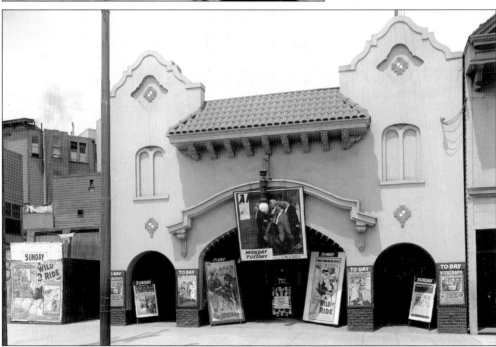

The Jose Theatre operated from 1913 to 1919 at 2362 Market Street. In later years it became Phillips Tire Company, then the home of the NAMES Project's AIDS Quilt; presently it is a popular restaurant with much of its original Spanish-style facade still in evidence.

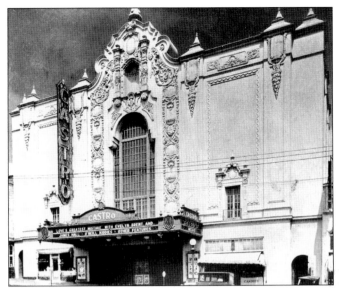

The Castro Theatre opened on June 22, 1922, at 429 Castro Street, and this 1927 view gives an accurate idea of its original appearance. It was designed by Timothy Pflueger, whose career supposedly originated with the Castro commission, and was built at a cost of $300,000 by the Nasser Brothers, whose family continues to operate it today. For the first 50 years of its existence, the Castro was never a first-run operation. It was simply an unpretentious link in the Nasser Brothers chain, a third-run house with moderately priced double features aimed at neighborhood residents.

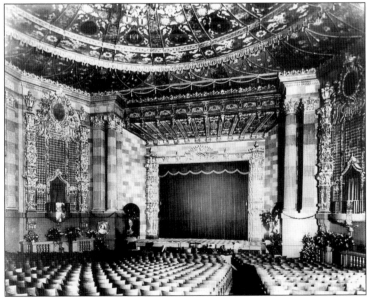

The Castro interior is seen here in 1922. In 1954, in order to properly deal with widescreen projection, the screen was moved from the original minuscule proscenium against the back wall to the front of the stage and extended from pillar to pillar. In October 1989, the Loma Prieta earthquake took a heavy toll on the rococo features, so some of what is pictured here is now gone; however, careful restoration over the ensuing years has kept the auditorium in otherwise near-vintage condition.

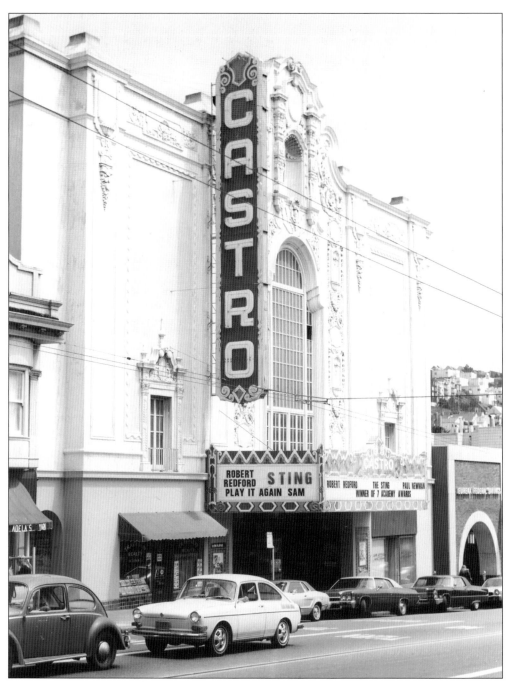

In July 1977, the Castro Theatre became the 100th San Francisco edifice to receive the protection and prestige of landmark status. Today it hosts a variety of film festivals of every conceivable nature, intermingled with unique programming, both vintage and contemporary, that guarantees its continued survival as a living theatrical venue. It is not just a relic of the past, but a very active San Francisco entertainment center of the present and future.

GRAND OPENING

SATURDAY, AUGUST 5th

SEARCHLIGHT THEATRE

28th & CHURCH STS.

New Theatre : Good Pictures
Latest Music

We are installing one of the latest models of the AMERICAN PHOTO-PLAYER, with all the Orchestral effects at a cost of $5000. Be sure to see and hear it.

Doors Open 1:30 p. m. Admission: Children 5c.; Adults 10c.

C. J. Collins ——— 3358 22nd St.

The Searchlight Theatre opened August 5, 1916, at 1596 Church Street. It operated under a nearly a dozen names during the next 50 years, most notably the Princess (1939) and the Rita (1945–1961), the home of German-language films. In its last years (1961–1965), attempts to go mainstream (as the Del Mar) proved unsuccessful. It is now the Church at San Francisco, the bright blue building on the northwest corner of Twenty-eighth and Church Streets.

Yes, there was a Noe, was at 3984 Twenty-fourth Street. Prior to that, Twenty-fourth Street had two smaller sites, the Vicksburg (1913–1924) and the Palmer (1917–1938). The Noe opened on January 14, 1937, and closed on June 11, 1952. The problem seemed to be the programming. By the time big films got to the Noe, everyone had already seen them, either on Mission Street or at the Castro, and a lot of lesser films, such as *Old Los Angeles*, would have been better off not being shown at all. After being used intermittently as a church, the structure was eventually torn down and replaced by a supermarket.

The New Potrero Theatre at 312 Connecticut Street opened as the Alta in 1914, was renamed the New Potrero in 1930, and closed in 1963. It relied strictly on the neighborhood trade (it did not even advertise in the newspapers), and the fact that such an enterprise survived into the 1960s is nothing short of amazing. The Grateful Dead are said to have rehearsed here in the late 1960s for the recording of their *Anthem of the Sun* record. Today the structure has been remodeled and houses small offices.

The Roosevelt Theatre opened on September 22, 1926, at 2795 Twenty-fourth Street. After a period of presenting both English- and Spanish-language films in the 1950s, it reopened as the York 24 in an attempt to get in on the international trend. This didn't work, however, and it soon went all-Spanish as the York. After being closed for several years, it has recently been reinvented as Brava! for Women in the Arts, a live venue.

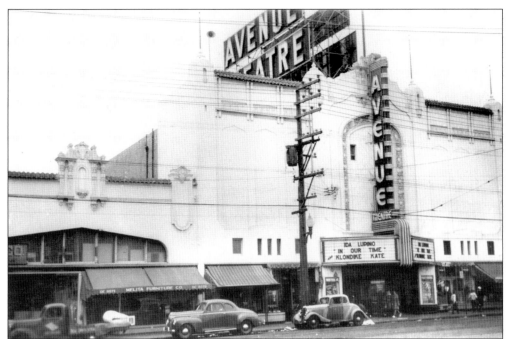

The Avenue Theatre at 2650 San Bruno Avenue opened on July 20, 1927, and operated for the next 40 years as the neighborhood anchor. In the mid-1960s, it was taken over by Edward Millington Stout III and the Lyric Photoplay Film Society, who installed a Wurlitzer pipe organ (originally built for Chicago's State Lake Theatre). It began a new life offering a potpourri of classic silent, sound, foreign, and even vintage three-dimensional films aimed at every possible taste. Despite having loyal regulars, the increasingly unsafe nature of the surrounding neighborhood ate away at the Avenue's patronage, and the theatre closed permanently on December 22, 1984. It now stands vacant.

The Bayshore Theatre at 2428 Bayshore Boulevard opened in 1926, serving the neighborhood trade of Visitacion Valley. It closed on October 15, 1957, as a result of diminishing patronage and became Mt. Olivet Baptist Church. It has since been torn down.

The Bayview Theatre opened in 1924 at 4935 Third Street, replacing the earlier Bay View Nickelodeon that had previously operated at 1101 Railroad Avenue (the earlier name for Third Street). It closed in 1957, was torn down, and was replaced by the Bay View Federal Savings building.

The South San Francisco Opera House was built in 1888 at 4705 Third Street at a time when the Bayview district was known as South San Francisco. Properly landmarked, it is the city's oldest surviving theatrical structure and serves today as a community center.

Six

WEST OF TWIN PEAKS

The sprawling western half of San Francisco, much of it originally covered by sand dunes, was the last to be developed, but didn't waste any time in catching up once things got going. As each new neighborhood took shape, theatres large and small soon sprung up to serve their immediate inhabitants, and a few of them survive today still serving that same basic purpose.

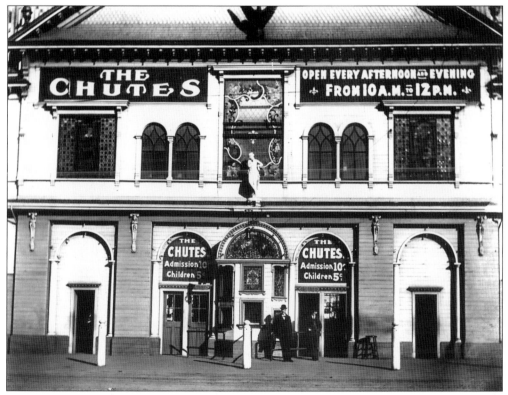

San Francisco's second of three Chutes Amusement Parks opened on May 1, 1902, on Fulton Street from Tenth to Eleventh Avenues. It offered the same sort of amusements as its predecessor on Haight Street (plus a small nickelodeon for movies and a 3,600-seat theatre for live shows). A month after the devastation of the earthquake and fire of 1906, the Chutes Theatre was temporarily renamed the Orpheum in order to replace, at least for a time, its totally destroyed downtown counterpart. When a more substantial Orpheum was built on Ellis Street, the Chutes Theatre regained its original identity and continued in service until the opening of the third and final Chutes Amusement Park on Fillmore Street in 1909.

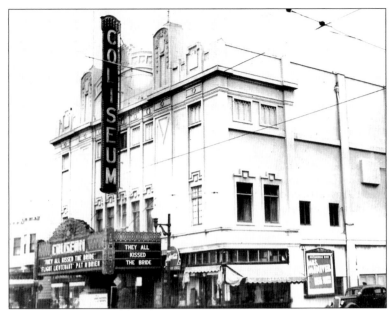

The 2,015-seat Coliseum Theatre at 745 Clement Street opened November 22, 1918. Designed by the Reid Brothers, it was the first (and largest) link in Samuel H. Levin's chain of second-run neighborhood theatres. Within the next 10 years, this chain would include the Metropolitan (later Metro), Alexandria, Harding, Balboa, New Balboa, and West Portal (later Empire). Damaged beyond repair by the Loma Prieta earthquake of 1989, it never reopened. It has since been rebuilt into condominium apartments upstairs and a Walgreen Drug Store downstairs, with much of its historic facade restored and preserved by the developers.

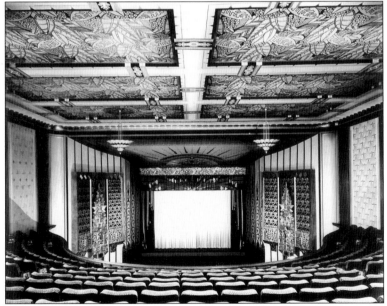

In 1931, the Coliseum was given a complete art deco makeover resulting in this eye-popping view of the auditorium. Unfortunately, over the years, tastes in decor changed, much of the detail was painted over, and the auditorium was eventually draped, so that all that remains of this wonderful moment in time are a few faded photographs.

The Alexandria Theatre at 5400 Geary Boulevard was designed by the Reid Brothers and built at a cost of $350,000. It was opened on November 26, 1923, by Samuel H. Levin and was the flagship of the circuit. In 1941, the Alexandria received a moderne redo—its original 1923 Egyptian decor was almost completely obliterated—and this is the way it looked (with only minor alterations) for the next 60 years. Long-run, reserved-seat, roadshow attractions became its trademark, beginning in 1958 with a 48 week engagement of *South Pacific*, followed by such crowd pleasers as *Cleopatra* (1963–1964, 56 weeks), and *Oliver!* (1968–1969, 43 weeks).

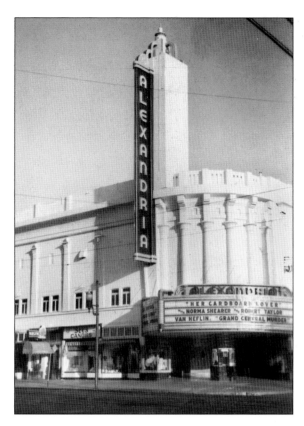

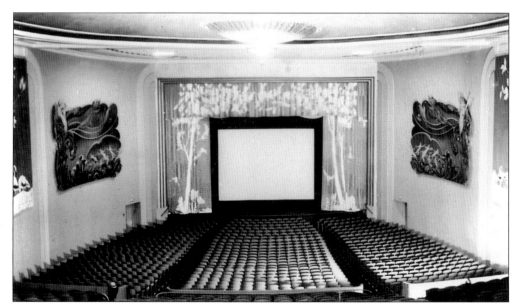

From 1941 onwards, the Alexandria's seating was officially 1,610 and remained so until 1976, when the upstairs balcony and loge sections were converted into two smaller theatres, the Alexandria 2 and 3, while the main floor remained more or less the same. It closed February 5, 2004, to face an uncertain future.

The Four Star Theatre at 2200 Clement Street opened in 1913 as La Bonita. It was renamed the Star in 1927 and Four Star in 1946. This wonderful 1919 photograph shows a patron trying to decide whether or not to invest 25¢ to see Gloria Swanson in Cecil B. De Mille's *For Better, For Worse.*

By the late 1960s, a new false front failed to disguise the original architecture of the side wall, and the Four Star was still thriving as a second-run house. After closing in 1990, it was reopened in 1992 by Frank Lee with Hong Kong films and became a twin in 1996 when a second cubicle was formed out of the right rear corner of the main floor. As we go to press, it looks like the end of the line of the Four Star as a movie theatre. Word is that a Korean church group has taken out a lease on the site.

The Balboa Theatre at 3630 Balboa Street was designed by the Reid Brothers and was opened by Samuel H. Levin on February 27, 1926, as the New Balboa. The name was in order to avoid confusion with the other Balboa Theatre that Levin was already operating on Ocean Avenue. After a disastrous fire in the 1970s, it was converted into a twin and is operated today by Gary Meyer. No photographs of its interior as a single-screen theatre seem to have survived, but it was similar to Levin's Empire minus the balcony.

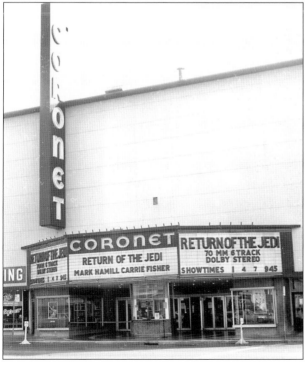

The Coronet at 3575 Geary Boulevard was designed by Cantin & Cantin for San Francisco Theatres and opened on November 2, 1949, making it San Francisco's first major postwar structure. After six years as a second-run neighborhood house, it was upgraded to a first-run, reserved-seat venue with *Oklahoma!*, which opened on February 16, 1956, and ran for 44 weeks. This was immediately followed by *Around the World in 80 Days*, which ran 94 weeks between 1956 and 1958, setting the all-time San Francisco long-run record. Other lengthy runs included *Ben Hur* (1959–1961, 75 weeks), *Funny Girl* (1968–1969, 59 weeks), and *Star Wars* (1977, 29 weeks). The Coronet closed on March 17, 2005, to be converted into senior citizen housing.

The Irving Theatre opened on June 10, 1926, at 1332 Irving Street, taking the place of several smaller theatres that had previously supplied the Inner Sunset with entertainment in nearby locations. With an extremely narrow audience base (Golden Gate Park on the north and the undeveloped Sunset Heights to the south), a dearth of patronage caused its closure July 8, 1962, and it was torn down.

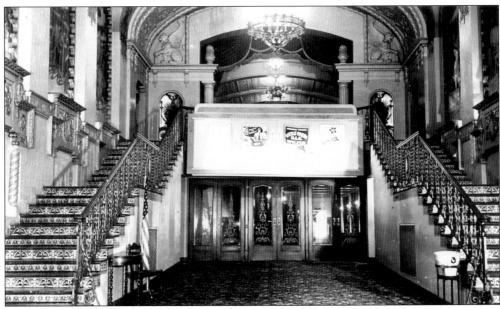

The inviting, Spanish-style lobby of the Irving offered twin-tiled staircases to its upstairs mezzanine and balcony seating.

The Parkside Theatre at 733 Taraval Street opened on December 28, 1928. Like so many others, it was modernized in the mid-1930s, and this handsome vertical became not only the theatre's identifying trademark, but that of the neighborhood as well. A 1965 remodeling destroyed all this and left it with a different front that lasted until the theatre's demise in July 1988. It has since been rebuilt into a child care center.

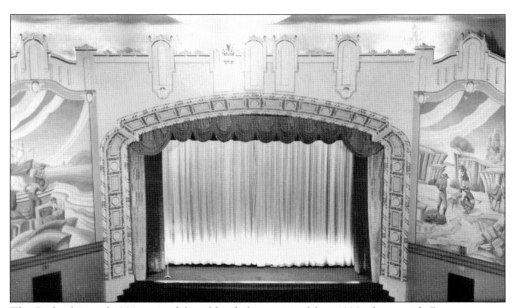

The Parkside's mid-1930s remodeling blended its original late-1920s decor with Depression-era murals in a pleasing fashion. This was all hidden behind the customary 1960s draping, so few people today recall it as it originally was.

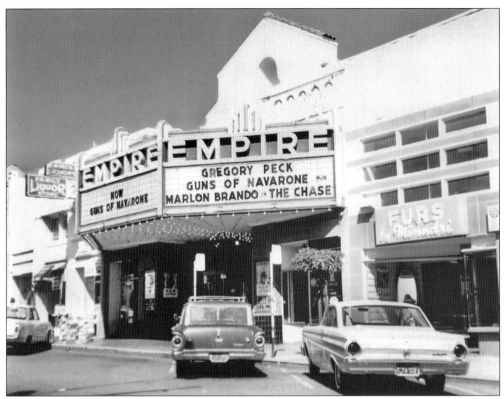

The Empire Theatre opened as the West Portal at 85 West Portal Avenue on December 26, 1925, and reopened on October 1, 1936, as the Empire. It was designed by Morrow & Garren and was operated by Samuel H. Levin. A popular neighborhood house, in the 1970s it was tri-plexed and renamed the Empire 3 on June 26, 1974. It continues to operate today as Cinearts at the Empire offering "new art and independent films."

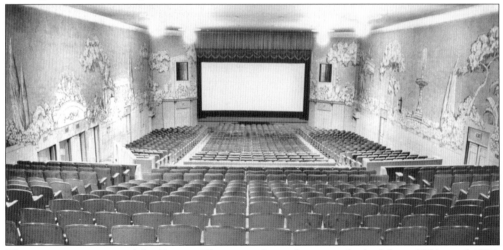

The attractive interior of the Empire Theatre is shown here as it looked from 1954 until 1974. Two smaller theatres have since been carved out of what was once the upstairs balcony and loge section, and little of the original downstairs section still appears as it once did in this vintage photograph. (Courtesy Steve Levin.)

El Rey Theatre at 1970 Ocean Avenue was designed by Miller & Pflueger in what could probably be described as Spanish art deco. It opened on November 14, 1931, and instantly became the anchor of the business community along Ocean Avenue. In the theatre's glory days, its 1,750 seats were often filled to capacity, but time, television, increasing overhead, decreasing patronage, and the downscaling of the neighborhood took their toll. It closed permanently as a theatre on April 1, 1977. It has since found new life as the Voice of Pentecost church and survives today under their direction.

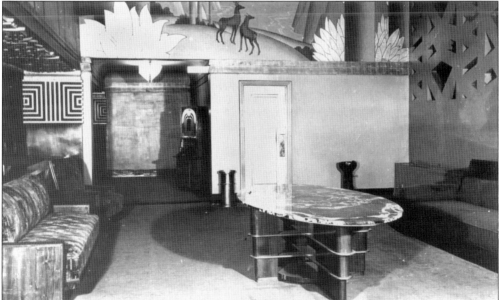

The mezzanine lounge of El Rey bespeaks the very definition of art deco, the prevailing style of furniture and decor at the time of its construction but a style that fell out of favor in later years. If this space remained intact today, it would be preserved and revered by today's art deco devotees; sadly, all that is left are these photographs.

Samuel H. Levin's first Balboa Theatre at 1634 Ocean Avenue opened in 1922 and was named after the Balboa district that it served. Outranked in 1931 by the nearby El Rey in both grandeur and size, it closed in 1932, after having briefly been renamed the Westwood, and was soon torn down to make way for a grocery store.

The UA Stonestown at 501 Buckingham Way opened on November 9, 1970, as a 965-seat, single-screen theatre adjoining the Stonestown Shopping Center. A few years later it was twinned by simply constructing a wall down the middle of the auditorium and as such, continues to operate today as part of the Regal Entertainment Group.

Seven

MULTIPLEXES

Multiplexes are here to stay, and, if film exhibition is to continue, they are the only economically practical way of doing it. Many people bemoan the loss of single-screen theatres but fail to look at the situation from the side of reality. The income generated by the minuscule number of people attracted to a large percentage of today's films could never begin to cover the overhead of showing them in a single-screen theatre. Moviegoers want the widest possible variety of films to choose from, and if a lot of these films are to be exhibited at all, multiplexes are the only answer. In these places, the income from each screen contributes to the cumulative total necessary to defray the ever-escalating costs of operation.

The Kabuki Theatre at 1881 Post Street opened in the 1970s as the Japan Center Theatre, offering live shows, but it was not well received. In the 1980s, it shut down and was completely redesigned into American Multi-Cinema's Kabuki 8, opening on December 5, 1986. It was an instant success. Having established itself as the city's pioneer film exhibition format of the future, the Kabuki's revolutionary concept was welcomed by a new generation of film fans. It has also been the home to the San Francisco International Film Festival since 1987.

The Galaxy Theatre was built at 1285 Sutter Street at a cost of $7 million by the United Artists Theatre Circuit. It opened on February 17, 1984, as a four-plex, revolutionary in both architectural design and concept. Today it is operated by Regal Entertainment Group.

The AMC 1000 Van Ness Avenue, which opened July 10, 1998, was developed out of the historic Cadillac Building by American Multi-Cinema. With 14 screens, a total seating capacity of 3,146, and an adjacent 400-space parking garage, it is a multiplex in every sense of the word. (Courtesy Terry Photo.)

The Opera Plaza Cinemas opened on November 16, 1984, at 601 Van Ness Avenue as a four-plex devoted to foreign, art, and independent films. Two of its auditoriums are so small that its operators (Landmark Theatres) call them "screening rooms." Keep in mind, however, that the size of the potential audience for many of these films is equally small. Without this option, many of these films would never be shown at all.

Landmark's Embarcadero Center Cinema on the promenade level of 1 Embarcadero Center was developed out of preexisting space and opened in July 1995 with five screens, varying in seating capacity from 130 to 300 for a grand total of just 1,000 seats. Foreign, art, and independent films are the fare here, and the site has proved a popular destination for local filmgoers seeking something beyond what is offered in the mainstream venues. (Photo by Terry Photo.)

Loew's Metreon at 101 Fourth Street is San Francisco's ultimate multiplex, offering 14 screens plus a giant IMAX. It embodies everything loved and hated about these places: mainstream movies, often shown in multiple auditoriums, big wide screens, state-of-the-art technology, stadium-style seating, fast-food dining, computerized Internet ticket service, and validated parking. The Metreon uses every possible perk to attract today's mass audiences in the largest possible numbers. It is the wave of moviegoing in the 21st century and what future historians will some day look back upon as the good old days. (Photo by Terry Photo.)